REALITY RECORDED

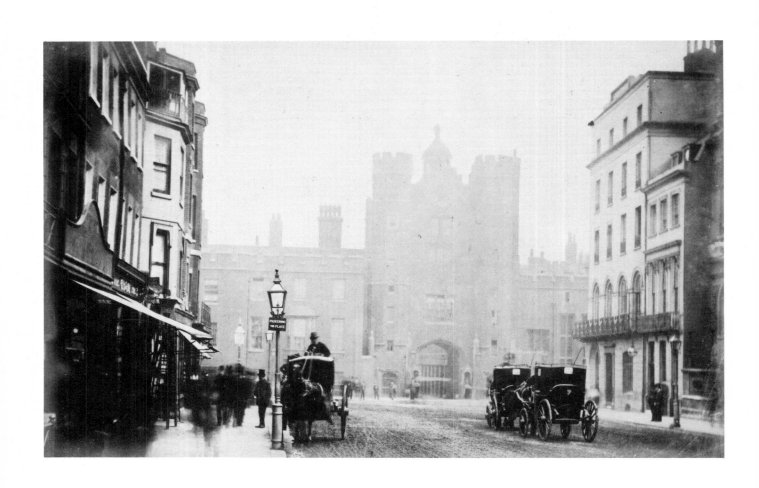

WILLIAM WILLOUGHBY HOOPER: *St James's Palace, London, 1876.*

REALITY RECORDED

Early Documentary Photography

GAIL BUCKLAND

DAVID & CHARLES

NEWTON ABBOT · LONDON

0 7153 6217 8

Set in 'Monotype' Van Dijck
and printed and bound in Great Britain
by W & J Mackay Limited Chatham Kent
for David & Charles (Holdings) Limited
South Devon House Newton Abbot Devon

Designed by John Leath

Contents

Picture Credits

TO

Barry

WHO HELPS ME SEE
AND UNDERSTAND

Acknowledgements

I should like to thank Dr D. B. Thomas, Keeper, Science Museum, for reading the final draft of the manuscript and for offering many helpful suggestions. I deeply appreciate the help given to me by my husband and Miss Francesca Kazan during the preparation of the book. I should like to thank Mr John White, former librarian of the Royal Photographic Society, for assisting me in my research and for help with the bibliography and index.

I have received support from many people while working on the book and I could not possibly mention them all here. I should, however, like to thank the following people for their assistance: Mrs Veronica Bamfield; Arthur Gill; June Stanier; John Hannavy; Mr Robert Mackworth-Young, Librarian, and Mrs Else Benson and Miss Teresa Fitzherbert, Royal Library, Windsor; Mr Kenneth Warr, Royal Photographic Society; Miss Joanna Drew, The Arts Council of Great Britain; Mr Brian Coe, Kodak Museum; Mr W. Eglon Shaw, The Sutcliffe Gallery; M André Jammes; M Jacques Wilhelm, Musée Carnavalet; Mr Peter Castle and Mr Christopher Hobbes, Victoria & Albert Museum; Mr Roy Ainsworth and Mr W. J. Nowell, Dr Barnardo's; Mrs Dorothy Castle and Mr George Dugdale, Royal Geographical Society; Miss Marion Allum, National Army Museum; Mr M. Brennan, Imperial War Museum; Mr B. T. Carter, National Maritime Museum; Mr D. J. Stagg, Ordnance Survey, Southampton; Mr Andrew Birrell, Public Archives of Canada; Mr Harold White; Harvie Zemach-Fishtrom; Mrs Katherine Michaelson and Mr Anthony Fruish of A. C. Cooper Ltd for making many of the fine reproductions used in the book.

We are now making history, and the sun picture supplies the means of passing down a record of what we are, and what we have achieved in this nineteenth century of our progress.

<div align="right">

JOHN THOMSON
Proceedings of the
Royal Geographical Society
1891

</div>

Foreword

During March and April 1972 the Arts Council of Great Britain sponsored an exhibition entitled 'From today painting is dead' – The Beginnings of Photography. This was a very large exhibition covering the history of photography up to the advent of the dry plate, around 1884. I accompanied Dr D. B. Thomas, Deputy Keeper at the Science Museum, London, and organiser of the exhibition, in the very enjoyable task of visiting numerous photographic collections throughout England. Together we looked at thousands of early photographs and selected those we found most interesting to be shown at the exhibition at the Victoria & Albert Museum, London.

When I was approached by the publishers to do a book based on the exhibition, I accepted the offer readily. The exhibition brought great enjoyment to thousands of people who were not familiar with early photography. The public, by not being exposed sufficiently to the charm and uniqueness of early photographs, has been denied visual documents of their own history. *Reality Recorded* hopes to bring the past alive by showing photographs taken by men who believed fervently that this new medium – photography – could document life.

The exhibition was much broader in scope than this book, which contains very little technical information and hardly any photographs that are 'straight' portraits or 'art' photography. These topics are covered in other books. It is specifically a look at early documentary photography and the extraordinary individuals who recorded with calotype and wet-plate cameras those things they felt to be important. Whether they were photographing the royal family, the building of the Crystal Palace, the American Civil War, or mental patients, the early documentary photographers were involved with the problems, advancements and events of their day. In this respect, they are the precursors of today's photo-journalists.

The invention of photography must be seen as the beginning of modern visual communications. It can be argued that the introduction of the camera as a means of passing on information has had as big an impact on our society as the arrival of the printing press. An understanding of today's media is dependent on an awareness of the first, the 'primitive', photographic images created over one hundred years ago.

1 Documentation in a Changing World

Great changes were taking place throughout the world while photography was still in its infancy. The use of steam and gas together with the development of the railways were of increasing importance as the population rapidly changed from being basically rural to urban. It was a period of major building, and a great transformation took place in the cities and towns. Not all the changes were grand. Photographers had very few prejudices and looked at the world with open eyes. The camera recorded a quiet street in Paris as precisely as it did the building of the Crystal Palace. The camera was a tool with which the photographer could express how he felt about his own personal world. The documentary photographer felt the need to interpret his environment in concrete, visual terms. He knew that as a photographer he could be selective and factual as regards subject matter. The camera could not only capture minute detail but also the atmosphere of the place.

Before photography could be a tool to record efficiently, it had to go through a series of modifications. A brief look at the work of the early inventors in the development of photography will help give the reader a much greater appreciation of the photographs in this book.

The earliest permanent photographic images were produced by the Frenchman Joseph Nicéphore Nièpce (1765–1833) in 1825–7. Called heliographs, they were pewter plates coated with the light-sensitive asphalt, known as bitumen of Judea, dissolved in oil of lavender. Nièpce was partially successful in obtaining camera photographs by exposing for several hours. These images were quite indistinct.

W. H. F. TALBOT: *building Nelson's Column, Trafalgar Square,* c *1844.*

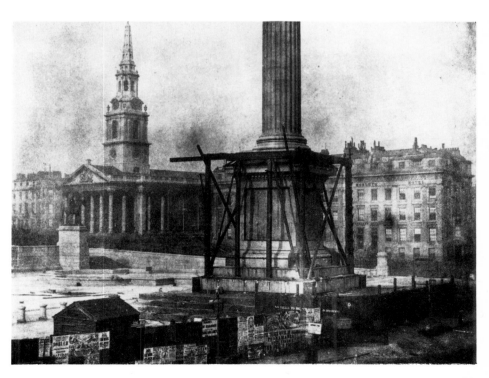

Far more successful than Nièpce in producing high quality camera images was Louis Jacques Mandé Daguerre (1787–1851) who had been in partnership with Nièpce from 1829 until 1833. The heliographic process was very insensitive and Daguerre realised the necessity of developing a new process. His procedure was to coat a copper plate with a thin layer of silver. The silver surface was first polished and then sensitised with iodine and bromine. The plate was then ready for exposure in a camera. After exposure the image was brought out by the action of mercury vapour; fixing was done with hypo. On the 7 January 1839, the French physicist Arago announced Daguerre's discovery at a meeting of the Académie des Sciences although the details were kept secret until August 1839. Portraiture was not possible at this time as exposures lasted from several minutes to more than half an hour. Improvements were made and by 1841 portraits were being taken in France and England and the United States. Daguerreotypes were popular during the whole of the 1840s, especially in France and America. It was, however, a dead-end process. The daguerreotype was indeed beautiful, but was costly and the image could not be reproduced over and over again.

It was an Englishman, William Henry Fox Talbot (1800–77), who invented the photographic process that evolved into modern photography. It was the negative-positive aspect of Talbot's discovery that allowed for inexpensive, reproducible images. Talbot had been working since 1833 on trying to capture the image of the camera obscura directly on to light-sensitive paper, and in August 1835 he permanently recorded a negative image. These photogenic drawings, as they were called, needed exposures of about one hour. In September 1840 Talbot discovered that a brief exposure of one to three minutes produced a 'latent' image which could be revealed through development with a suitable reagent. This new process was called the calotype (from the Greek word *kalos* meaning beautiful) or Talbotype process. To produce a calotype negative, writing paper is washed with silver nitrate solution and then dried. It is then placed in a solution of potassium iodide, washed with water, and again dried. When required, the paper is treated with a freshly prepared solution of gallo-nitrate of silver (a mixture of silver nitrate, gallic acid and acetic acid). The paper is then exposed in the camera. The image is brought out by a further treatment with gallo-nitrate of silver, and after washing, is fixed with hypo. This negative is then brought into contact with common writing paper that has been soaked in a salt solution, dried, and then coated with a solution of ammonia and silver nitrate. After sufficient exposure to light, an image appears on the writing paper which is then fixed with hot hypo solution and washed. Talbot patented his process in 1841 and consequently this marvellous invention could not be practised freely until 1852 when the patent was suspended (except for taking portraits for profit which, as previously, was still patented).

In 1851, however, a new and better way of making photographs was announced by Frederick Scott Archer (1813–57). Archer's process, given free to the world, was known as the wet-collodion or wet-plate process. This new process produced negatives on glass. This was accomplished by coating a piece of glass with a solution of iodised collodion and just before exposure, dipping the glass into a solution of silver nitrate. The plate had to be wet during exposure in the camera and then immediately developed and fixed. The result was a finely detailed negative that had a shorter exposure time than either the calotype or the daguerreotype. It quickly superseded these and became the photographic process for many an ambitious, intelligent, and creative individual until the popularisation of 'dry-plates' in the early 1880s.

The wet-collodion negative was normally printed on albumen paper, which was introduced by Blanquart-Evrard in May 1850. The paper was coated with albumen from whites of eggs containing salt and sensitised before use with silver salts. Albumen was the main printing paper until around 1890.

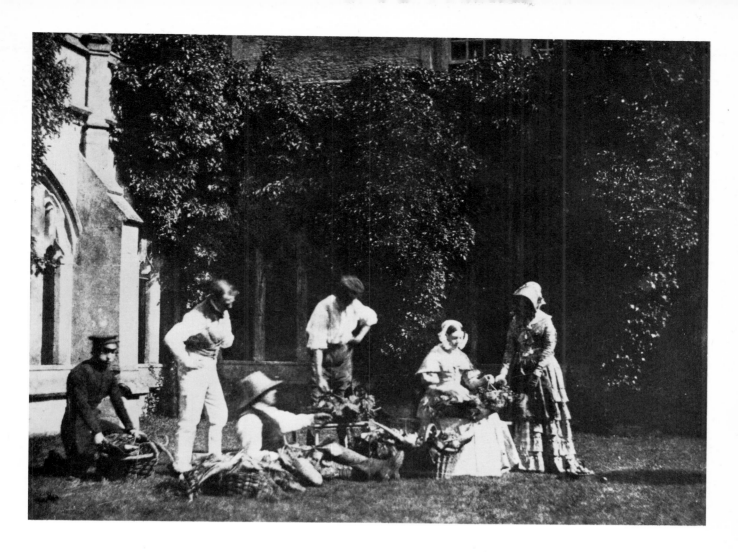

W. H. F. TALBOT *or friend: group at Lacock Abbey, Wiltshire,* c *1844.*

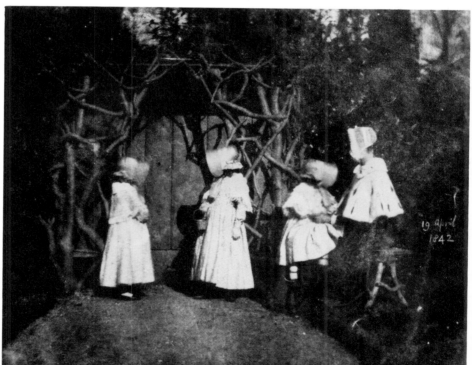

W. H. F. TALBOT: *Talbot's children, 19 April 1842.*

Photography had arrived and people, events, places, and works of art could be accurately recorded. This first chapter takes a look at what was happening and how things appeared in the years of the calotype and the wet-plate photograph.

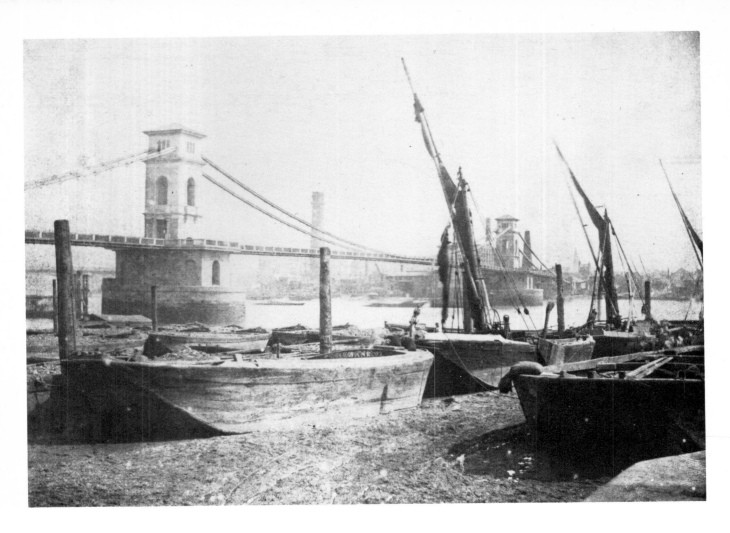

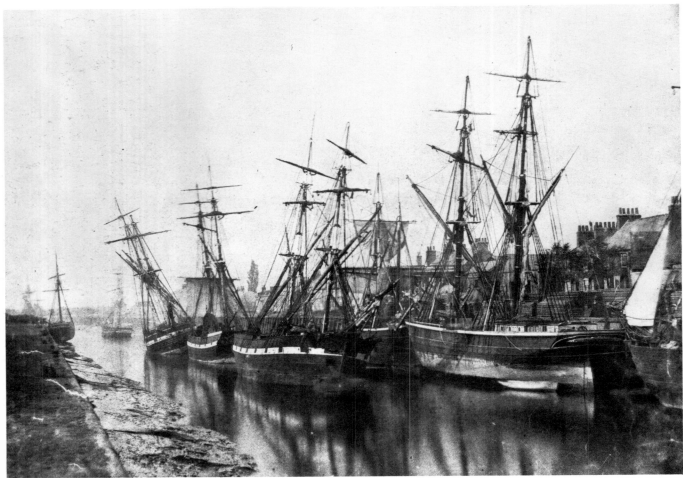

W. H. F. TALBOT: *Hungerford Suspension Bridge, c 1845. Designed by Brunel, and opened as a toll-bridge in 1845: it was taken down in 1862 to make way for the present Hungerford Railway Bridge.*

Samuel Smith (1802–92) was a wealthy amateur photographer from Wisbech, Cambridgeshire. He always used a paper negative process even after wet-plate photography became popular. There are no known negatives of Smith's after 18 May 1864.

The bottom photograph on the opposite page was probably part of a series of photographs exhibited locally in Wisbech to help the local townspeople understand a proposal for a new dock. The caption on the mount reads: 'Vessels at extreme left hand in distance show the upper end of bends of river proposed to convert into a dock.' The exposure was fifteen minutes, as the day was dull.

Smith exemplifies the early photographer who realised the importance of photography as a documentary medium and an educational tool. He recorded only a small area around his home and did so with great understanding of the changes taking place in his own locale. Like many, many photographers, his name is virtually unknown and it is only recently that Mr Brian Coe, curator of the Kodak Museum, England, has uncovered a large body of this photographer's work.

SAMUEL SMITH: *vertical steam engine and four men on the quayside, Wisbech, Cambridgeshire, c 1854.*

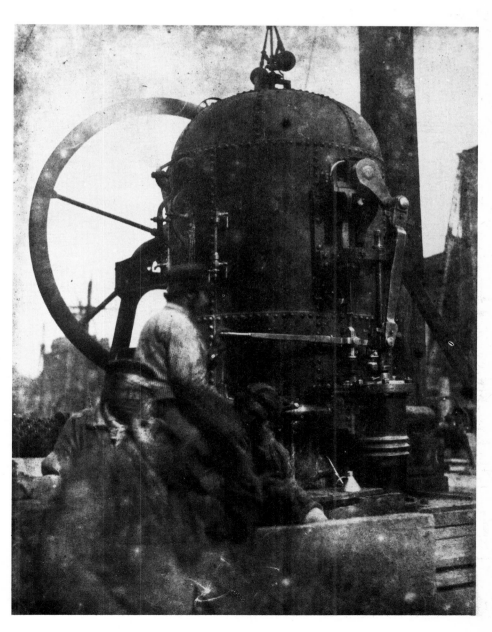

SAMUEL SMITH: *looking upstream. Part of the river at low water above proposed dock, September 1861.*

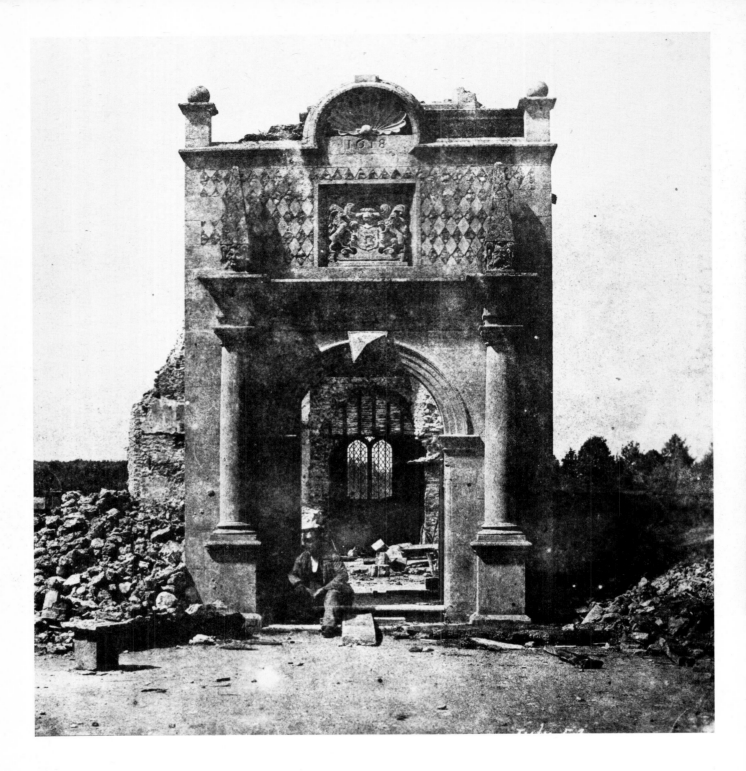

The photograph was taken soon after a fire that destroyed the hall, built in 1618; the gateway was the only thing that survived. As it was taken during the cleaning up of the rubble, wheelbarrows, planks, etc, are apparent. The 'ghost figure' could possibly be Smith himself as he obviously was not in the picture for the entire length of the exposure. Hunstanton Hall was subsequently rebuilt.

SAMUEL SMITH: *Hunstanton Hall, July 1853*.

The facing illustration is the result of seven exposures of Edinburgh – Castlehill, Tolbooth St John Church, the New College, the Castle, the National Gallery, Cowgatehead, the Candlemaker Row. Keith was trying to capture the essence of Edinburgh on one negative.

Scottish-born Thomas Keith (1827–95) was an early amateur calotypist. A doctor by profession, he apparently took up photography in 1854 and used the

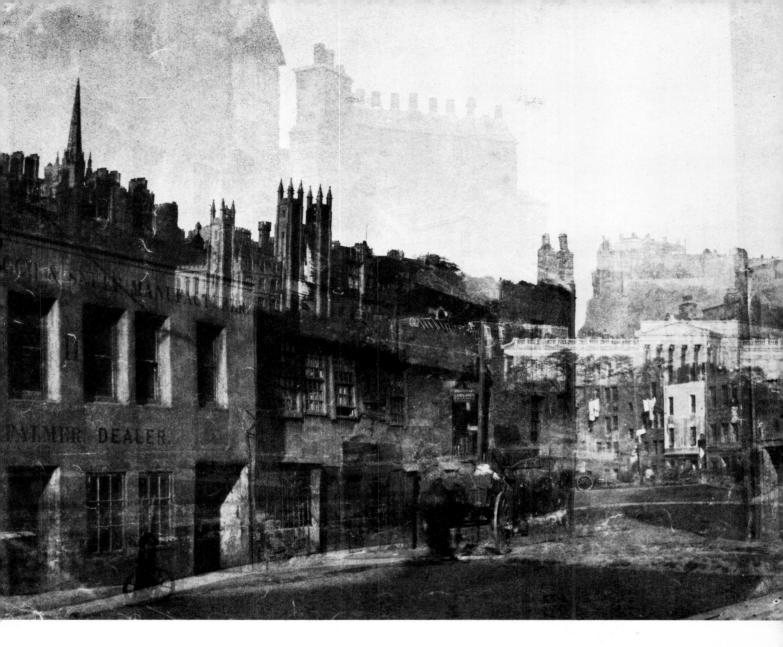

THOMAS KEITH: *multiple exposure, Edinburgh, 1854–6.*

waxed-paper process (a method developed by the French photographer Gustave Le Gray to make paper negatives more convenient). He mostly photographed buildings and landscapes, exclusively in summertime when the light was at its best. This would mean taking photographs before 7 am or after 4 pm when the light was soft and the shadows large. His exposure times were from two to eight minutes.

On 10 June 1856 Keith read a paper to the Photographic Society of Scotland which was reported in Thomas Sutton's periodical *Photographic Notes*. In it he said:

> I am quite satisfied that the commonest cause of failure arises from the paper being exposed to a bad or indifferent light, especially in town, where the atmosphere is so much adulterated with smoke . . .
>
> I would recommend anyone who thinks of trying this method [waxed-paper] to keep his nitrate bath of good strength, never to expose in bad light and to use the paper freshly sensitised, and I believe after a little practice he will find it will require some trouble to occasion a failure.

There is no evidence that Dr Thomas Keith continued photographing after 1856. His medical commitments had become very great and his health irregular. He took over 220 photographs.

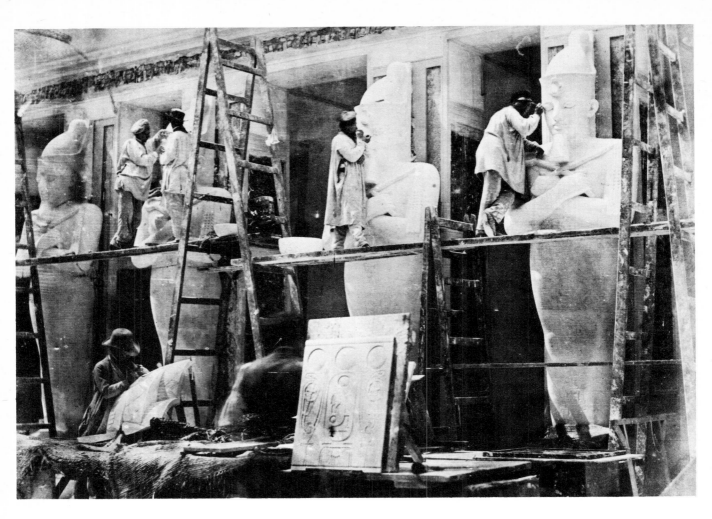

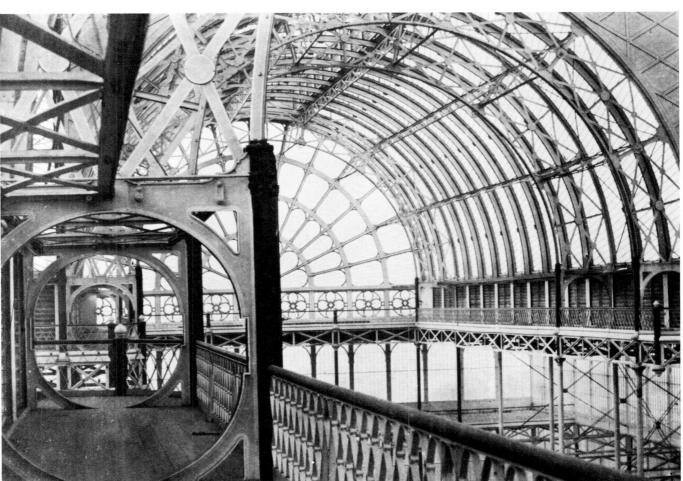

P. H. DELAMOTTE: *setting up the colossi of Rameses the Great*, c 1853.

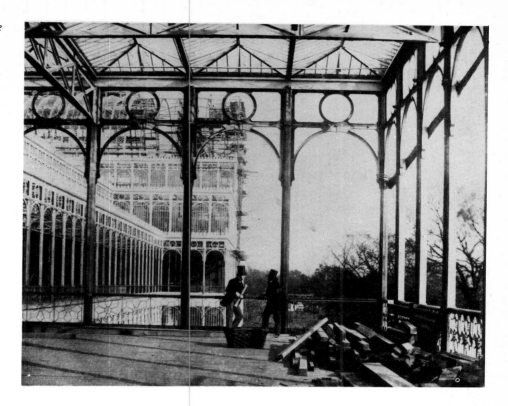

P. H. DELAMOTTE: *the Open Colonnade*, c 1853.

P. H. DELAMOTTE: *the Upper Gallery*, c 1853.

The original Crystal Palace was built in Hyde Park and housed the Great Exhibition of 1851, the first international exhibition ever held. It was a display designed to show the world all the new and most up-to-date inventions, innovations, etc. The Great Exhibition served to stimulate interest in photography. Not only were photographs exhibited but they were also included in the *Reports of the Juries*, (1852), which was illustrated with 155 calotypes.

Philip Henry Delamotte (1820–89) was commissioned by the directors of the Crystal Palace Company to take photographs of the works in progress of the re-building of the Crystal Palace in Sydenham. Formerly an artist and early calo-typist, Delamotte documented completely and creatively the building of the

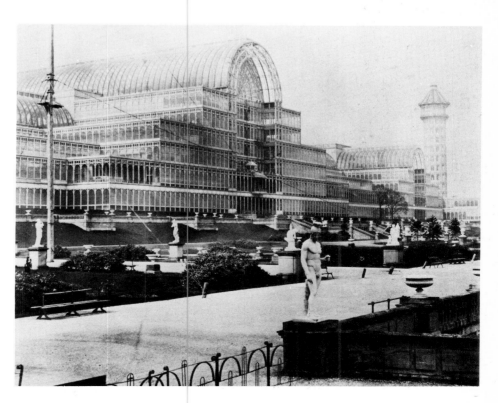

P. H. DELAMOTTE: *the Crystal Palace at Sydenham*, 1859.

Crystal Palace from the levelling of the site in 1851 to the opening ceremony conducted by Queen Victoria on 10 June 1854. Every week Delamotte took photographs and his complete work, originally published in two volumes, is a magnificient achievement and a superb example of how imaginatively a wet-plate photographer could document events.

The Crystal Palace served as a site for exhibitions, concerts, etc, until 1936 when it was destroyed by fire.

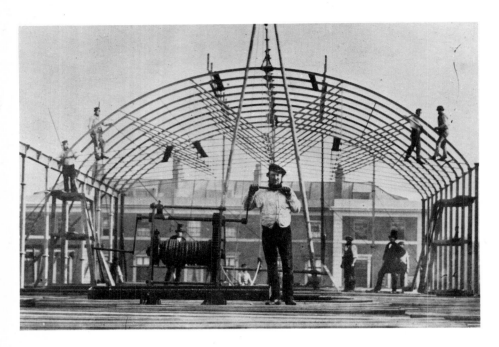

SERGEANT SPACKMAN *of the Royal Engineers: building the first of the museum buildings, 7 April 1856.*

UNKNOWN: *the Palace of Westminster, during construction of the Albert Embankment. This embankment was planned mainly for flood prevention and opened in 1869. The paddle-boat was drawn-in after the photograph was taken, and the Houses of Parliament were heavily retouched.*

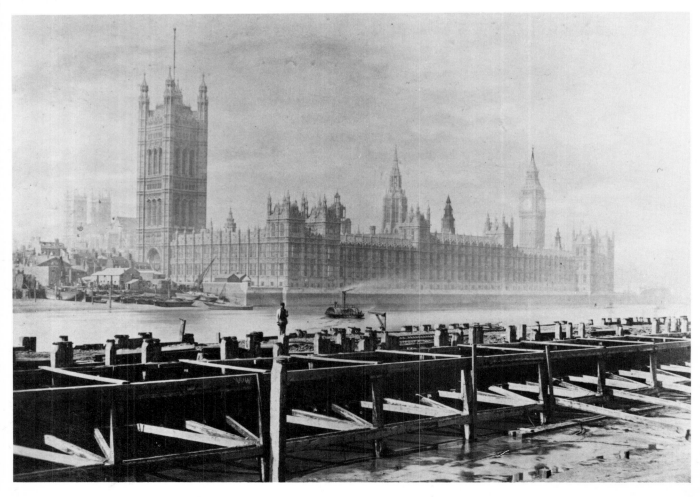

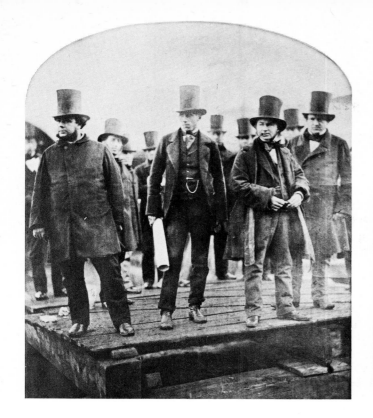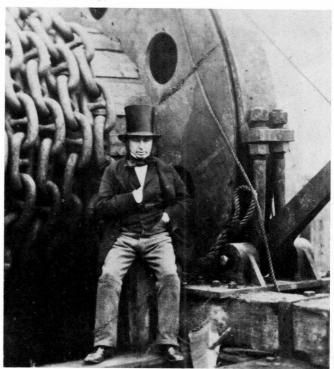

Above: UNKNOWN: *launch of the Great Eastern, 31 January 1858, with (left to right) J. Scott-Russell, Henry Wakefield, I. K. Brunel, Lord Derby.*
Above right: LONDON STEREO-SCOPIC AND PHOTOGRAPHIC COMPANY: *I. K. Brunel in front of the launching chains of the* Great Eastern.

The *Great Eastern* was designed by I. K. Brunel, famous for the engineering of the Clifton Suspension Bridge. The ship, designed to carry 4,000 passengers, had six masts and five funnels. She was 692 feet long, had a tonnage of 22,500, carried 6,500 square yards of sail and her 11,000 horsepower drove a 58 foot paddle wheel. She could store 15,000 tons of coal in order to eliminate frequent refuelling. The ship was originally christened the *Leviathan* but the name *Great Eastern* appealed more to the general public.

Robert Howlett and Joseph Cundall were commissioned by the *Illustrated Times* to take photographs of the *Great Eastern*. Cundall's partner George Downes and Robert Howlett produced a set of fifteen stereoscopic slides of the *Leviathan*. A reporter from the *Illustrated Times* in an article appearing in the paper for the 16 January 1858 commented on this set as follows:

> ... Photography, when first discovered, seem to have a noble mission before it, which it was prepared to perform with a reverent spirit; namely, to seize the opportunity offered for the art-education of the masses. Gladly did we welcome the marvellous photographs of Egypt, Switzerland, the Louvre, &c, which were offered us at so reasonable a rate, and which served, in a measure, to correct that bilious feeling evoked in us by the shop windows of our art-publishers. After turning away in pious horror from a 'Sherry, sir!' or an equally vulgar and conventional 'Group of Choristers!' the eye rested with exquisite satisfaction on a placid, natural photograph, which assumed no meretricious charms to woo you, but won you by its very modesty and truthfulness.

When photography had been brought to that stage of perfection which now renders it the most valuable assistant to the artist—in lieu of being its enemy, in which light he was at first inclined to regard it—the invention of the stereoscope seemed destined to give the finishing touch of reality. Unfortunately, the result has proved just the opposite; and the curse peculiar to England, that nothing can become popularised among us without becoming equally vulgarized, was visible in this instance. Before long our shop windows became thronged with stereoscopic slides, while the art became the nucleus of a separate profession. It is true that at first the stereoscopic artists adhered to

truth, and gave us principally representations of antique statues, natural scenes, and buildings; but, before long, some adventurous genius introduced the taint of vulgarity, and doubtless made his fortune rapidly. The most absurd 'made up' subjects, in which it was a moot-point whether the execution or the design were the worst, were eagerly purchased by the middle classes, and the stereoscope nuisance was rapidly assuming the dangerous proportions of the barrel-organ atrocity . . . How far this evil is destined to extend it is impossible to foresee; we, trust, however, that the present bold efforts made by Messrs Downes and Howlett to return to nature and the legitimate use of the stereoscope will meet with due success, for they truly deserve it for the delicacy of manipulation and the artistic taste displayed in selecting the various subjects . . .

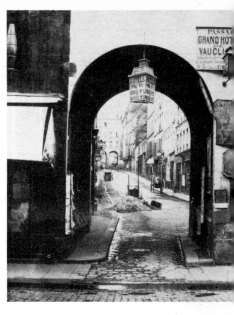

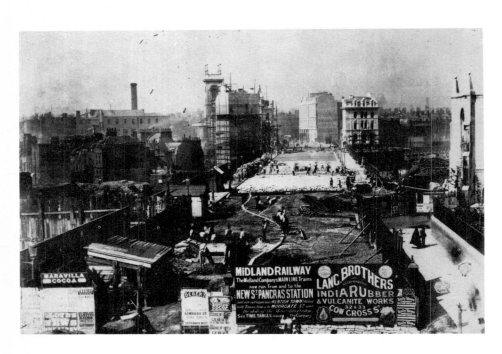

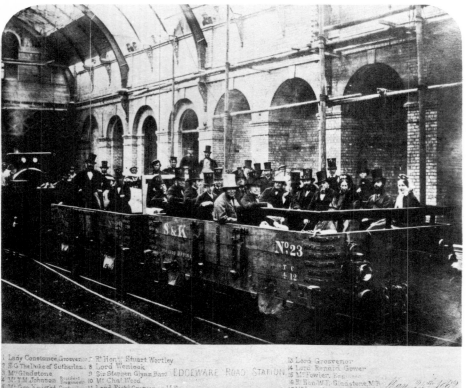

UNKNOWN: *Holborn Viaduct under construction, 1869.*

UNKNOWN: *the opening of London's first underground railway, 24 May 1862.*

This photograph of Gladstone (on right of the man with the white top hat) and others appears in a book titled *London Metropolitan Railway from Paddington to Finsbury Circus* with photographs to illustrate the works in progress, published in 1862.

In 1862 the first section of London's underground Metropolitan Railway was opened. It was commonly known as 'The Sewer' and carriages were merely open trucks. Passengers were deafened by the noise and choked by the smoke of this latest advancement in public transport. On the opening day some 30,000 travellers went simply for the ride.

Charles Marville was an excellent and prolific architectural French photographer. In the 1850s he worked for Blanquart-Evrard photographing religious edifices. At this time his fellow photographers, Hippolyte Bayard, Edouard Baldus, Gustave Le Gray, Henry Le Secq, and Mestral, were working for the French government agency called the 'Commission des Monuments Historiques' set up in 1851. The agency was concerned with the preservation of ancient buildings and appointed the five photographers to make a thorough survey of its architectural monuments.

In 1865 Marville photographed the streets of Paris, often during rainy days, in order to bring out the texture of the cobblestone streets, so typical of old Paris. His documentation of Paris before the great changes occurred in the city enacted by Napoleon III and Baron Haussman is a personal statement by a perceptive and sensitive photographer about the city he knew so well.

CHARLES MARVILLE: *Passage Tivoli*, c 1865.

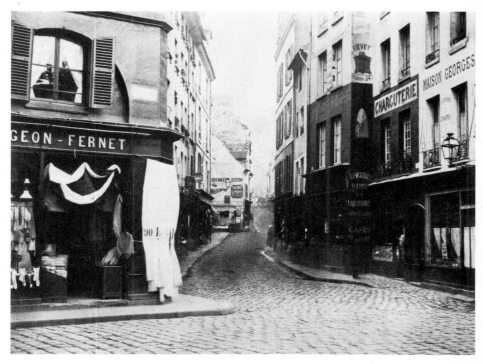

CHARLES MARVILLE: *rue Mouffetard (de la rue Loureine)*, c 1865.

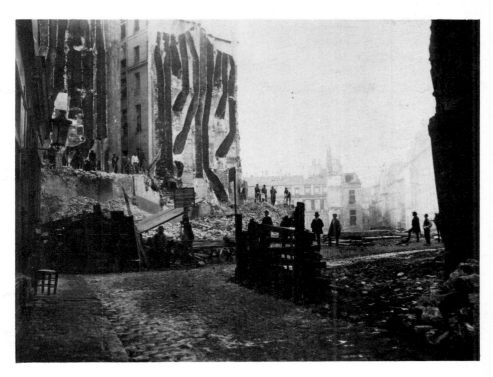

CHARLES MARVILLE: *tearing down of the Avenue de l'Opéra; building site of the rue d'Argenteuil, near the rue Faubourg Saint-Honoré*, c 1865.

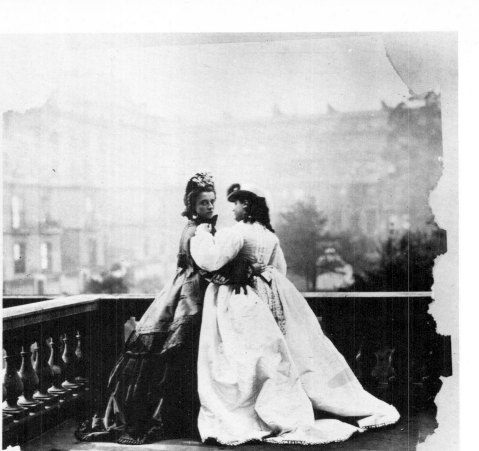

Clementine Elphinstone was born in 1817, the daughter of a Spanish woman. In 1845 she married Cornwallis Maude, fourth Viscount Hawarden (1817–1905). They had one son and five daughters, and it is their children that appear in Lady Hawarden's photographs. Little is known of her life or photographic career except that she won a few medals in the early 1860s for photographic composition. She died in January 1865.

UNKNOWN: *Broom House, Fulham, before 1866.*

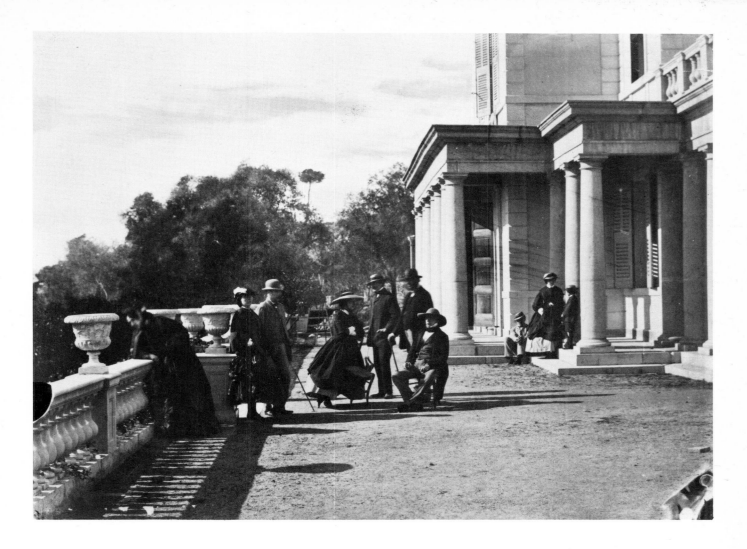

CHARLES NÈGRE: *Lord Brougham at Cannes.*

Charles Nègre (1820–80) was a painter who had studied under Ingres and Delaroche. He started taking photographs in 1851 and his images reflect his artistic training. The photographers Gustave Le Gray and Henri Le Secq helped and advised Nègre. His photographs are among the most beautiful 'sun pictures' (the name given to early photographs) ever made.

The above photograph is included in this chapter because it depicts so subtly a certain style of dress and demeanour of the upper class at this time. Photography is able to show how people looked and dressed: it can also capture the atmosphere and character of a group when employed by a creative and competent artist.

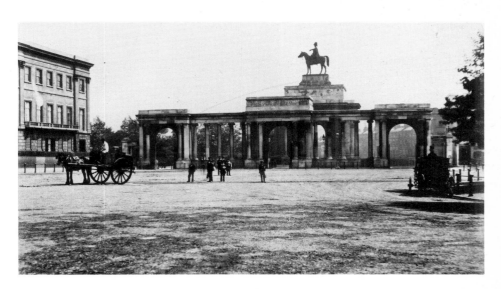

ROGER FENTON: *Hyde Park Corner, c 1856–7. Although the gateway still remains, one hardly recognises Hyde Park Corner without the traffic.*

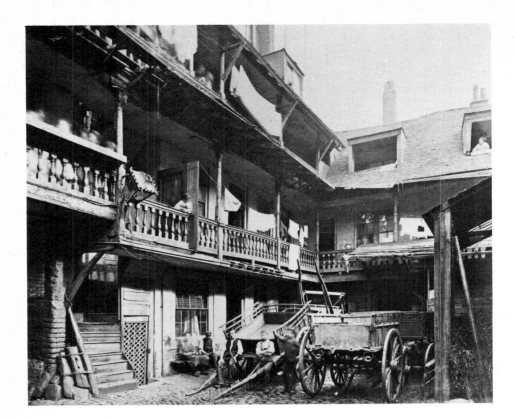

This is one of a series of four photographs of Warwick Lane, London, acquired by the Victoria & Albert Museum on 6 November 1876 for twelve shillings. The Oxford Arms, an example of a galleried inn, was demolished in 1878. The forecasted demolition of the Oxford Arms stimulated a group of photographers to take action. *The Times* of 6 July 1877 explains the situation as follows:

> When the ancient hostelry was about to be pulled down in 1875, a few artists and others interested in the antiquities of London determined to secure photographs of the ancient building, and so preserve the one thing about it which was really worth preservation. The proposal was made known in our columns, and we received so much support that it was resolved to continue the work in similar cases, and a 'Society for Photographing Relics of Old London' is now in existence . . . The photographs now published are clear, permanent, and taken from well-chosen points of view.

Most of the photographs of the society were taken by Henry Dixon and A. and J. Boole. When the society came to an end in 1886, 124 carbon prints with descriptive notes had been issued to each subscriber.

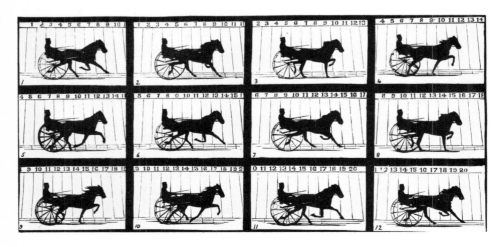

EADWEARD MUYBRIDGE: *the horse Occident in rapid motion, 1877.*

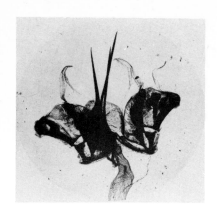

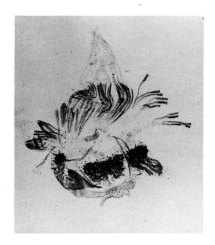

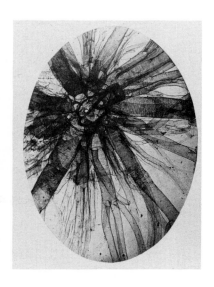

A. BERTSCH. Top: *bee sting*. Centre: *luminous organ of a glow worm*. Above: *caterpillar trachea*.

Adolphe Bertsch (d 1871) was a French photographer who made improvements in the speed of collodion plates and around 1860 designed a camera, an enlarger and shutters. He produced excellent photomicrographs from 1853 onwards, which were albumen prints from wet-collodion negatives.

Both William Henry Fox Talbot and the Rev Joseph Bancroft Reade had made photomicrographs in the late 1830s. Fox Talbot was probably the first person to take photographs of magnified objects. According to his *Account of the Art of Photogenic Drawing* (1839), Talbot made photographs of objects magnified seventeen times in the summer of 1835.

Reade, it is believed, made his experiments with the solar microscope in 1838. This would pre-date Talbot's publication mentioned above, but not Talbot's earliest experiments. Taking photographs through the microscope was of great assistance to the scientist, who before could rarely draw his specimens accurately.

In 1872 Eadweard Muybridge first photographed the horse Occident, which belonged to the millionaire Leland Stanford. Stanford had wagered $25,000 with a friend that when a horse is rapidly trotting it, at one point, has all feet off the ground. He employed Muybridge to make records of the moving horse with 'instantaneous photographs'. In May 1872 Muybridge made several negatives of Occident at the Union Park Race Course in Sacramento, trotting laterally in front of his camera at speeds varying from two minutes and twenty-five seconds to two minutes and eighteen seconds per mile. Although these photographs and the ones taken the following year have not been located, we know that Stanford found them satisfactory to win his wager, but Muybridge never claimed them to be more than 'photographic impressions'.

Muybridge's experiments were suspended during the years 1874 to 1876 due to unhappy events in his personal life (see page 39). By 1876, however, he had returned from Central America and confronted Stanford with a new method of photographing a horse in motion. He claimed to be able to take photographs at 1/1000 of a second, and by 1877 his much improved photographs of the trotting Occident were distributed to newsmen and caused a considerable furore.

The immediate effect of Muybridge's photographs were most strongly felt by horsemen and artists. The latter could no longer draw a galloping horse as they 'saw' it, but had to conceive its movements in scientific terms based on Muybridge's experiments.

Throughout 1878 to 1879 Muybridge was engaged in experiments at Stanford's Palo Alto Farm. In 1878 he was using twelve cameras with electro-shutters; in 1879 he increased the number of cameras to twenty-four and started photographing athletes jumping, fencing, tumbling, etc. Muybridge prepared the pictures for publication, binding sets of original prints into a number of albums which he titled *The Attitudes of Animals in Motion* and copyrighted in his own name in 1881. He then travelled abroad meeting eminent scientists such as Etienne-Jules Marey and artists such as Meissonier, and gave popular public lectures. He returned to America in 1882 and for the next two years was engaged in public speaking on the topics 'The Attitudes of Animals in Motion' and 'The Romance and Reality of Animal Locomotion'.

Eadweard Muybridge is best known today for his work which was published in the fall of 1887 as *Animal Locomotion*. These photographs were chosen from over 100,000 studies of humans and animals he made at the University of Pennsylvania during 1884 and 1885.

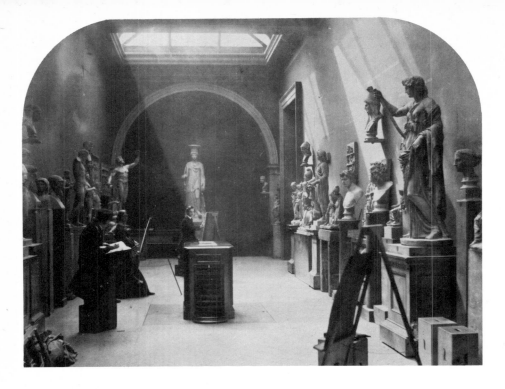

ROGER FENTON: *Double Bridge on the Hodder, August 1858.*

Roger Fenton worked at the British Museum from late 1853 to 1859. In March 1854 his appointment as staff photographer was confirmed by the Trustees. For approximately four months a year Fenton photographed works of art belonging to the museum. His prices were high and he charged twice as much to photograph inside the museum as to photograph a work of art in daylight on the roof of the museum itself. The Trustees showed great foresight in establishing the position of staff photographer and in choosing Fenton who was brilliant in photographic technique. The above photograph is atypical of Fenton's British Museum work in that it shows people in the museum. Most of his photographs, printed both on salted and albumen paper, are records of pieces of ancient sculpture. Today, the only known collection of these photographs are at the Royal Photographic Society, the British Museum stating that they have no examples.

One of the most important applications of photography is in the reproduction of works of art. Before the invention of photography, the layman and the scholar were dependent on artists to try to accurately reproduce paintings, sculptures, architecture, etc. Obviously, these handmade reproductions were only interpretations of the original and it was not until photography took over this field of endeavour that people had faith in the reproductions they saw. For the first time they could see in a reproduction the texture of the surface of a sculpture and the correct proportions in a painting or drawing.

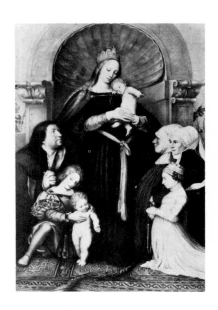

With photography came the dissemination of knowledge about works of art from all over the world. People had the opportunity to study reproductions in books, periodicals, stereocards, and *cartes-de-visite* of objects of great beauty that they would otherwise never be able to see. For the first time people could judge art works for themselves and many a 'masterpiece' was considered otherwise by the public and numerous unknown works were acclaimed. History of art books had to be rewritten.

Photography popularised art and allowed many artists to receive handsome incomes from the profits of mass distribution of their work. It helped the artist in many ways, and perhaps its greatest service to the artist was to free him from the responsibility of verisimilitude in his work, thus allowing him to be more expressive and creative.

UNKNOWN: *photographic reproduction* c 1870 *of 'Die Madonna' by Hans Holbein.*

30

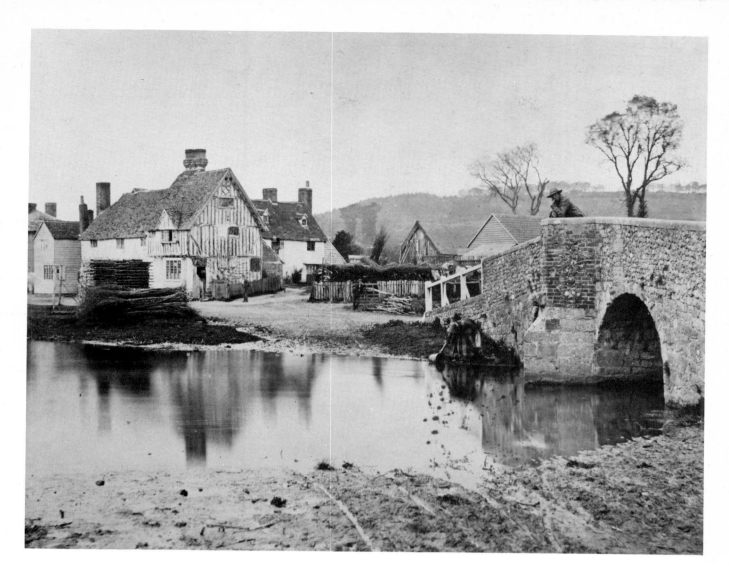

FRANCIS BEDFORD: *A Peaceful Village, published in* The Sunbeam, *1859.*

Francis Bedford (1816–94) was a leading landscape and architectural photographer of the 1850s and 60s. He was invited by Queen Victoria to accompany the Prince of Wales and his party on a tour of the Holy Land in 1862. A series of forty-eight of the 175 photographs he took on the trip were published in *The Holy Land, Egypt, Constantinople, Athens, etc.* (1866).

ROGER FENTON: *the British Museum,* c 1854.

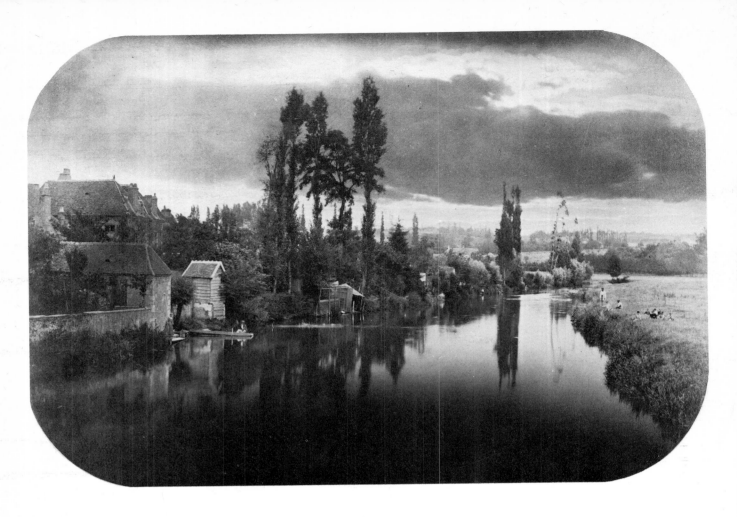

'Perhaps the gem of the whole exhibition (Photographic Society of Scotland, 1858) is 'River Scene – France' by C. Silvy. We have seen no photograph which has taken our fancy so much as that exhibited under this unpretentious title . . . The natural beauty of the scene itself rich in exquisite and varied detail with the broad soft shadows stealing over the whole, produce a picture, which for calm inviting beauty we have not seen equalled.'[1]

Camille Silvy was a Frenchman who set up a studio in London in 1859 and became the most successful and fashionable portrait photographer of the time, specialising in *cartes-de-visite*.

CAMILLE SILVY: *River Scene – France, 1858.*

UNKNOWN: *the photographic building of the Ordnance Survey office in Southampton, c 1859.*

The top of the building was used for photographing and printing. Printing frames with negatives can be seen around the balcony. Darkrooms were on the ground floor.

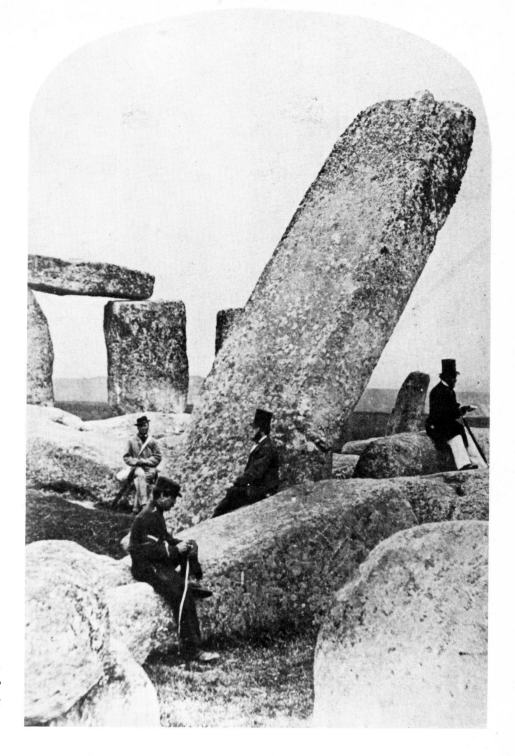

UNKNOWN: *Stonehenge, 1867. Taken for the Ordnance Survey to help to encourage the acceptance of plans for its re-erection.*

The Ordnance Survey has always found photography a great aid in its work and encouraged its growth. By 1867, for example, the Ordnance Survey had published five books each containing photographs. Of these, one was about the survey done of Stonehenge, one was of Jerusalem, and three were of the ordnance survey done in Sinai. The photographs in the last three volumes totalled 153. Any photograph could be purchased separately for 9*d* or 1*s* 0*d* unmounted, or 1*s* 6*d* mounted.

At the same time the Ordnance Survey was also offering eighty-five views as either photographs or photozincographs (a photomechanical printing process). They were also selling photozincographic facsimiles of parts of the Domesday book, national manuscripts, maps, etc. In 1862 a book titled *Photozincography and Other Photographic Processes Employed at the Ordnance Survey Office, Southampton* by Captain A. De C. Scott and Colonel Sir Henry James was published.

Rimington was a member of the Amateur Photographic Association whose president was HRH The Prince of Wales. The association had for its objective 'the printing and interchange of the productions of Amateur Photographers, in order that the thousands of interesting and valuable negatives, now buried in the plate-boxes of Amateurs, may be brought before the notice and placed within the reach of the general public'.

RIMINGTON: *off Cowes.*

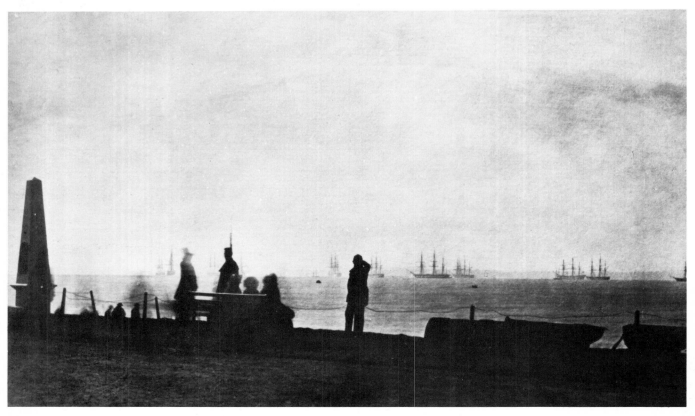

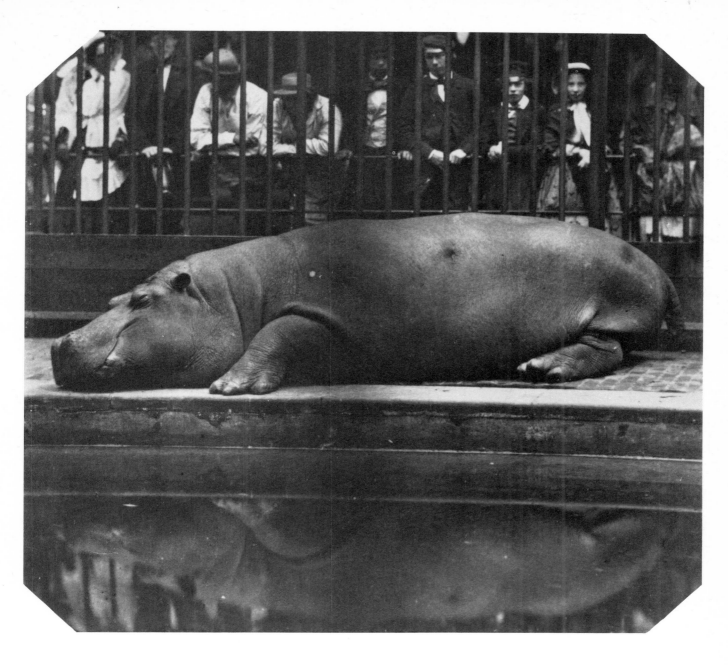

COUNT DE MONTIZON: *The Hippopotamus at the Zoological Gardens, Regent's Park, c 1854.*

'This animal was captured in August 1849, when quite young, on the banks of the White Nile; and was sent over to England by the Pasha of Egypt as a present to Queen Victoria. He arrived at Southampton on May 25, 1850; and on the evening of the same day was safely housed in the apartment prepared for him at the Zoological Gardens, where he has ever since been an object of great attraction.

'Taken on Collodion with a double Lens, by instantaneous exposure.'[2]

ROGER FENTON: *the Fleet at anchor, 11 March 1854.*

2 New Frontiers

One of the most exciting aspects of researching early documentary photography is the discovery of facts about the lives of the photographers and the circumstances under which they took their photographs. On the whole they constitute an extraordinary group of individuals. They displayed sheer determination, real bravery, superb skill, and a wonderful sense of excitement and adventure. Off they went with their calotype or wet-plate apparatus (the latter being very heavy and cumbersome) to every corner of the world. The difficulties they faced were often enormous but the satisfaction of being the first (or one of the first) men to record precisely a particular place made the challenge very worthwhile.

The photographers each had different reasons for going exploring with their

ROGER FENTON: *the new palace and cathedral of the Kremlin, from the wall, 1852.*

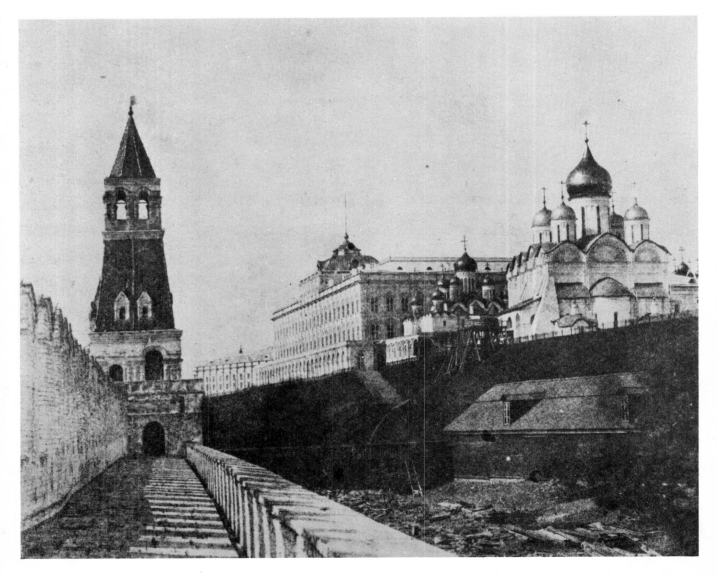

cameras. Maxime DuCamp (1822–94), who accompanied his friend Gustave Flaubert to the Middle East between 1849 and 1851, had a commission from the French Minister of Education to photograph monuments and sites in the Near East. The best 125 of the 200 calotype prints he took were printed at Blanquart-Evrard's Imprimerie Photographique and published in book form with text. *Egypte, Nubie, Palestine et Syrie* (Paris, 1852), the first travel book with actual prints, sold well, the subject matter being of great interest to most Frenchmen.

Using the waxed-paper process, Roger Fenton recorded impressions of Russia in the year 1852. Looking at the prints today the feel of mid-nineteenth century Russia is strongly conveyed; the salted-paper prints themselves look like relics of a vanished empire. The empty streets and bold outlines of the Russian buildings appear strange and mysterious on the coarse sensitised writing-paper. Fenton went to Russia on a commission to photograph the works in progress of a bridge being built over the Dneiper, designed for Nicholas III by Robert Vignoles. Vignoles, like Fenton, was to be one of the founders of The Photographic Society of London. Once Fenton finished his assignment, he travelled about Russia making a very fine set of documentary photographs.

One of the leading landscape photographers and publishers of continental and English views was Francis Frith (1822–98). In England, as in France, there was a great demand for views of the Middle East. Frith went on three expeditions there, the first being in 1856, to take photographs to sell as stereocards and prints, and for publication in books and portfolios. At this time photographers did not use enlargers for printing. Prints were made by contact printing, and to obtain prints of three sizes, the photographer would have to use three different cameras. The problems Frith faced in the 1850s when he travelled up the Nile (in 1859 going beyond the fifth cataract over 1,500 miles up the Nile) were numerous. He took with him three cameras – the largest taking 20 × 16 inch plates – and a wicker-work carriage, which served as a darkroom and for sleeping.

Frith was not very prone to giving advice to photographers but, on one occasion in 1858, he did say the following at a meeting of The Photographic Society:

> . . . I confess I am extremely careless, and scarcely know often what I use; at the same time, with ordinary materials, I scarcely ever fail to produce a picture of some sort. I do not prefer to work rapidly upon a landscape, from which I may pass away for ever, but rather slowly; for if you are working with rapid collodion half a second more or less exposure may spoil your picture. I prefer taking about forty seconds.[1]

The name of Frith became very popular as F. Frith & Co published more and more views from Frith's own negatives, or from those of his employees and other photographers with whom he had agreements. Around the turn of the century Frith of Reigate began the lucrative enterprise of producing and selling picture postcards, mostly of British towns, beauty spots, beaches, festivals, churches, etc.

> Having laid in a good stock of provisions and hermetically-sealed stores, and arranged them with cameras, chemicals, glass, tents, bedding, portmanteaus, and cooking utensils on the backs of sixty strong coolies (hardy mountaineers from Ladâk, who agreed to accompany us the whole journey), we left Simla on the 3rd of July [1867]. The south-west monsoon had already set in, but we were prepared for any amount of rain, as we knew too surely we should get it. Four easy stages along the capital Thibet road brought us to the village of Narkunda, where the picturesque travellers' bungalow formed my first picture.[2]

These are the words of Samuel Bourne (1834–1912), the Nottingham photographer who went to India, set up a photographic business in 1861 with a Mr Shepherd, and soon became the leading landscape photographer there. Bourne

was an extraordinary individual and a truly magnificent photographer. His work has a timeless perfection and although he was well aware of the limitations of photography, his work is not often equalled today. Relating his feelings on his second trip to the Himalayas (Bourne made three expeditions; in 1863, 1864, and finally in 1865–6 when he reached the Manirung Pass, 18,600 feet high) he made the following two statements concerning his craft:

> . . . The photographer can only deal successfully with 'bits' and comparatively short distances; but the artist, who has colour as well as outline to convey the idea of distance, might here find something worth coming for. If our artists at home, who are crowding on the heels of each other and painting continually the same old scenes which have been painted a hundred times before, would only summon up courage to visit the Himalayas, they would find new subjects enough for a lifetime, or a hundred lifetimes; and what is of importance, would find a ready sale in this country for their works. They would also furnish to people at home some idea of what the Himalayas are really like, which we of the camera can hardly do.[3]

and later:

> . . . Far be it from me to depreciate our beautiful art, or join the ranks of those whose interest, jealousy, or ignorance of its capabilities induced them to make unfair comparisons, and raise a stupid cry about its being a mechanical process, requiring little or no artistic skill and taste. I have as little sympathy with these as I have with those who would place its results on a level with the finest productions of colour, and who try as hard as they can to alienate the sympathies and good-will of artists by talking a lot of preposterous nonsense which, to impartial and sensible people, would be very amusing if it were not so outrageously absurd. But while I yield to none in admiration of the finest productions of photography, I cannot help remarking (and those who have had large experience with the camera in mountainous countries will bear me out in this assertion) that it fails more or less in the rendering of distances and mountains— the former appearing much too hazy and indistinct, the latter unnaturally dwindled down and distant. This remark, of course, does not apply to mountains which are close to the camera.[4]

Bourne wrote articles for the *British Journal of Photography* describing his adventures in the Himalayas. The trips alone took great courage and physical strength and, coupled with the fact that Bourne was using wet-plate apparatus all the time and in the most difficult of situations, one can only feel great admiration for a man so dedicated and proficient in his work. An excerpt from his writings about his third trip gives an example of the type of problems Bourne faced in securing his unique images:

> When I looked out next morning we were so completely surrounded and shut in by mountain walls that there seemed absolutely no passage out anywhere except that by which we had come. 'Tis true the stream still rolled on through the narrow opening before us, but now it was hemmed in by 2,000 feet of precipice on either side . . . I called my village guide, and, with a feeling of intense curiosity and a consciousness that I was giving him a poser, asked him to show me our path . . . I shuddered as I surveyed the nature of this perilous track, and plainly saw that, dangerous as the Manirung Pass had been, it was safety itself compared with this . . .
>
> One false step, one little slip, and I should have found myself in the stream and in eternity the next moment. I dare not look down in such places, but, my face to the rock, held on to the hand of my attendant who, being without shoes,

could secure a firmer footing. How my coolies with their heavy loads, some of them unwieldy things like tent-poles, ever contrived to get safely over this five miles of walking on a ledge, instant death staring them in the face at every step, remains a profound mystery to me at this day.[5]

Bourne's own words are the best complement to his photographs. Unlike so many photographers, Samuel Bourne realised that descriptive notes concerning the conditions under which certain photographs were taken greatly enhanced the value of the images for posterity.

A most remarkable photographic personality is Eadweard Muybridge (1830–1904), best known for his studies of subjects in motion. Because of the importance of his human and animal locomotion photographs, Muybridge's other photography is often overlooked.

Edward James Muggeridge (Muybridge's original name) left England in about 1850 for the United States, but it was not until 1867 that he became known as a photographer. In that year he travelled to Yosemite Valley, California, taking views on whole-plate and stereo cameras. The sale of some of these views in 1868 under the trade mark 'Helios, the Flying Studio' proved extremely successful. In 1868 Muybridge was appointed to accompany General Halleck in order to take views of the military ports and harbours of Alaska, newly acquired by America from Russia.

From 1868 to 1872 Muybridge was engaged by the Lighthouse Board and the Treasury and War Departments to take views along the west coast of the USA. He was particularly interested in documenting aspects of Californian life.

Again in 1872 Muybridge photographed in Yosemite, this time going for six months and taking a line of pack mules to carry his provisions and photographic supplies which included 20 × 24 inch glass negatives.

Late in 1871 or 1872 Muybridge married Flora Stone, a girl much younger than himself. In 1873 Bradley and Rulofson of San Francisco commissioned Muybridge to take stereoscopic pictures in North California of the Modoc Indian War. When he returned home in the fall of 1874 he learned that his wife had a lover, and shot him. Muybridge was charged with murder but was acquitted and released early in 1875. He received an assignment from the Pacific Mail Steamship Company to take photographs along their route through Central America and one month after his release he was in Panama. Muybridge travelled and photographed extensively throughout the west coast of Central America and Mexico. He produced photographs of subjects never before recorded with the camera, such as cultivation and preparation of coffee, life in Indian villages, ruins of Panama, etc. His photographs brought fame and $50,000.[6]

In 1877 Muybridge successfully photographed a horse in motion and until about 1892 he was engaged in studying animal and human locomotion. Around 1894 he returned to his home town of Kingston-upon-Thames where he died ten years later having lead a life full of adventure.

America produced many photographers yearning to explore the great 'wild west'. Among the most colourful and attractive was William Henry Jackson (1843–1942) called by many 'the grand old man of the national parks'. In 1866 he left Vermont and went west with a Mormon wagon train as a bull-whacker driving an ox team. In 1868 he started a photographic business in Omaha and in addition to his commercial work he travelled about the surrounding areas mainly photographing the local Indians.

In 1869 Jackson went on a photographic tour along the newly completed Union Pacific Railway. It was during this time that he met the geologist Dr F. V. Hayden. Hayden asked Jackson to accompany him on his 1870 survey and from then until 1879 Jackson was official photographer of the United States Geological Survey

Territories. In 1871 he photographed in the Yellowstone region; 1872 in the Grand Tetons; in 1873 in what is now the Rocky Mountain National Park; 1874 around south-west Colorado, and in 1875 went into the San Juan Mountains of Colorado with a camera that took 20 × 24 inch negatives. Many of these areas, such as Yellowstone, had never been photographed before. This should come as no surprise to anyone familiar with the photographic process used in the 1870s. The amount of equipment alone that the photographer needed was staggering. The following is a list of the items Jackson took with him on his first trip with the Hayden surveys:

Stereoscopic camera with one or more pairs of lenses
5 × 8 in Camera box plus lens
11 × 14 in Camera box plus lenses
Dark tent
2 Tripods
10 lbs Collodion
36 oz Silver nitrate
2 quarts Alcohol
10 lbs Iron sulfate (developer)
Package of filters
1½ lbs Potassium cyanide (fixer)
3 yds Canton flannel
1 Box Rottenstone (cleaner for glass plates)
3 Negative boxes
6 oz Nitric acid
1 quart Varnish
Developing and fixing trays
Dozen and a half bottles of various sizes
Scales and weights
Glass for negatives, 400 pieces[7]

Jackson's photographs of the West served to validate the tales that were told of the natural wonders that existed in North America. The photographs not only amazed the average American; they greatly impressed the members of the United States Congress – to the extent that they set apart Yellowstone region as a national park.

Jackson formed the Jackson Photograph and Publishing Company in Denver, and produced numerous stereo-cards for home viewing from the photographs he took while travelling around the country on horseback. Not only did Jackson travel across America, he also went around the world as a photographer for *Harper's Weekly* between 1894 and 1896. Knowing that Jackson travelled across half of Siberia gives a clue to the incredible stamina of the man who lived an active, adventurous, and creative life until his death at the age of ninety-nine.

There were many other glorious men who conquered new frontiers with camera at hand. To name them all would be an impossible task. To learn something about some of them gives our own lives a new sense of adventure.

There is an album of calotypes in the collection of the Royal Photographic Society by C. G. Wheelhouse titled *Photographic Sketches from the Shores of the Mediterranean*. The following note appears inside the front cover:

These photographs were taken by me in the years 1849–50 when in medical charge of a Yachting party consisting of Lord Lincoln, afterwards Duke of Newcastle and War Minister [in 1854] during the Crimean War; his brother

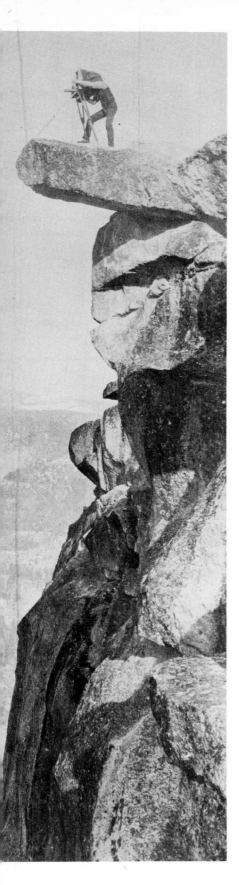

Lord Robert Clinton; Mr. Egerton Harcourt; and Mr. Granville Vernon of Grove Hall near Retford.

The photographs were taken by what was then called the Talbot-type process, a process only recently introduced by Mr. Fox Talbot, and a first endeavour to obtain 'negative' pictures, *on paper*, from which 'positive' ones could be printed at will, and as often as desired.

They were taken on simple paper, no glass plates or films having, at that time, been invented, and when completed were made as transparent as possible by being saturated with white wax, with the aid of a warm flat iron and blotting paper, by which means they were also made tough and durable.

On the completion of the tour these negatives were given to Lord Lincoln, and were all, unhappily, destroyed by a fire by which Clumber, his Lordships seat in 'the Dukeries', was nearly burned down in 1879, (March 26th).

C. G. Wheelhouse

Some of the captions to his photographs are extremely colourful and describe the problems facing the first photographers when they travelled in distant lands:

Lisbon – The Doorway of the Convent of San Geronimo.

This I believe to have been the first photograph ever taken in Portugal.

Photography, or as it was then sometimes called 'Heliography', had never been heard of there.

A market was being held around the Convent at the time I took it, and a mob soon collected around me, and would have been dangerous had I not been well guarded by members of the crew whom I had taken with me, in anticipation of some such difficulty.

Cadiz – Plaza d'Isabella Seconda.

This, my second attempt was more disastrous still!

To obtain it I had unwittingly got onto the fortifications and, just as I was congratulating myself on the prospect of a good probable success, an Officer and a dozen soldiers closed around and arrested me, believing me to be a spy taking a plan of the fortifications, and, certainly my apparatus looked very like it!

I was unable to explain my object, and was at once marched off to the Guard House.

Meanwhile the members of the crew who had accompanied me reported to Lord Lincoln what had happened and he put himself in communication with the English Consul (Mr. Brakenbury) who came at once to investigate the charge, and he, happily knew me having been [an] old schoolfellow!

He had never heard of photography, and did his best to explain that I was no spy – but the doctor in medical charge of the Yacht, practising a recently discovered art for obtaining picture by the aid of sunlight, and after long consideration succeeded in procuring my release after twelve hours detention.

Seville – The Guard House.

Here again I had hastily to snatch what I could get as the soldiers soon became alarmed at something quite new to them, and make my way to another point where I succeeded in getting a fairly good view of the market square with the Giralda tower of the cathedral in the distance.

Petra – El Khasneh, a temple hewn out of solid rock.

In the attempt to obtain this photograph and the others in Petra I should have been killed had I not been well guarded – the Edomites thinking I was a Magician and 'up to' something dreadful!

Jerusalem – The Walls and Davids Tower [a blurred photograph].

A very windy day – Camera unsteady.

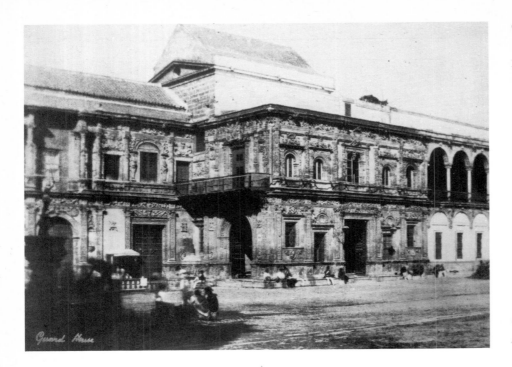

Opposite, top: FRANCIS FRITH: *Damascus, 1857.* Bottom: FRANCIS FRITH: *the Landing Place, Luxor, 1857.*

C. G. WHEELHOUSE: *the guard-house at Seville, 1849.*

The Rev Calvert Jones was a Swansea clergyman and a friend of Talbot. He went to Pompeii in 1846 and some of his negatives were purchased by Talbot in 1847. These were printed by Nikolaas Henneman (1813–75?), a Dutchman by birth and Talbot's former valet, at Talbot's Reading establishment (and possibly later at Talbot's establishment on Regent Street). The calotypes were sold to the public through stationers and bookshops.

Probably the REV CALVERT JONES: *the House of Sallust, Pompeii, 1846.*

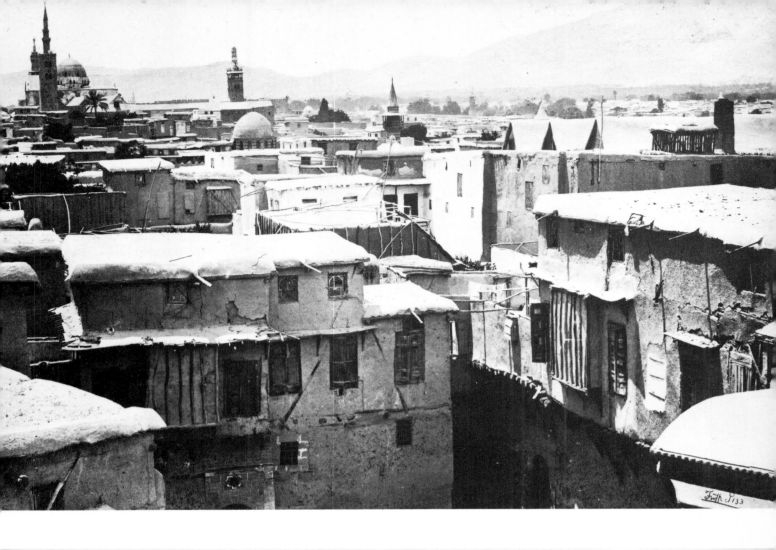

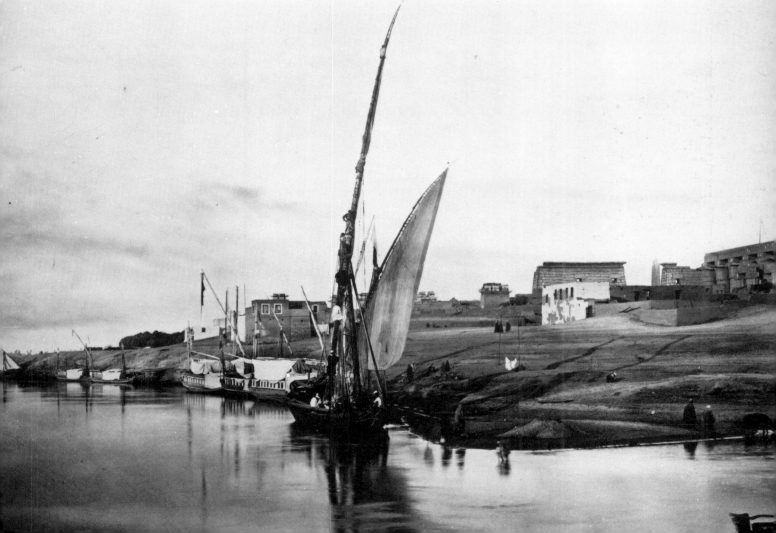

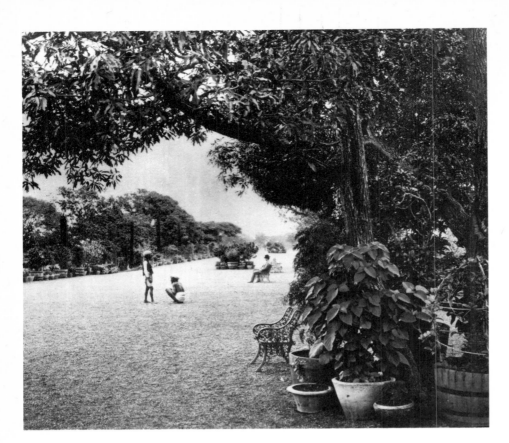

SAMUEL BOURNE: *Poona, the upper walk, Bund Gardens.*

SAMUEL BOURNE: *Darjeeling, group of Bhooteas.*

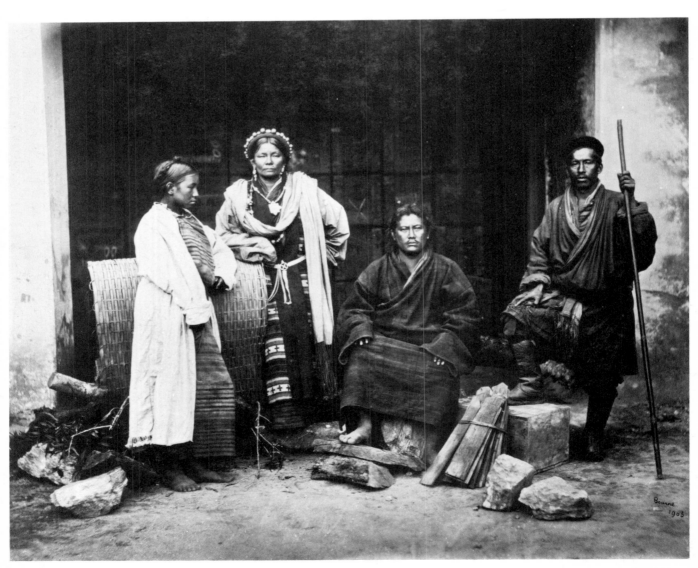

Samuel Bourne wrote:

Our next march brought us to the Beas, a considerable river which rises in the Rotung Pass, at the head of the beautiful valley to which it gives its name. It is sometimes called also the Kulu Valley, because it is the principal one in the Kulu district. The road lay for some miles along the left bank of the Beas, the sides of the mountains being here very steep, with few trees, but covered with grassy turf, affording ample pasturage for sheep and goats. Presently we had to cross the river, which was here about eighty yards wide, by means of 'mussocks', or inflated buffalo skins. These were not new to me; I had crossed rivers upon them before on my journey to Kashmir. But the doctor looked upon them with fear and misgiving, though he was too old a traveller and too much accustomed to the Himalayas to make any scruples about the matter, and forthwith committed himself to their buoyant inflation. I won't say he did not shut his eyes as the steersman pushed off, and he found himself being carried down the stream by the force of the current as rapidly as he was conveyed by the little paddles and feet of the steersman to the opposite bank. However, he stood on terra firma on the other side, while I had yet to cross. Running up the bank about 150 yards the men soon paddled back for me, after which all our coolies and baggage had to be brought across by the same means. This occupied about three hours, one of the loads nearly coming to grief by being carried down close to some rapids below, but was happily rescued by another mussockman who had discharged his load, and who, seeing the danger, rushed to the rescue in time to save the man and his charge.

While this was going on I grouped a number of the mussockmen with their skins on the river bank, and took a photograph of them, which to those unacquainted with this mode of crossing rivers looks a most mysterious picture.[8]

SAMUEL BOURNE: *mussocks for crossing the Beas, below Bajoura, 1865 or 1866.*

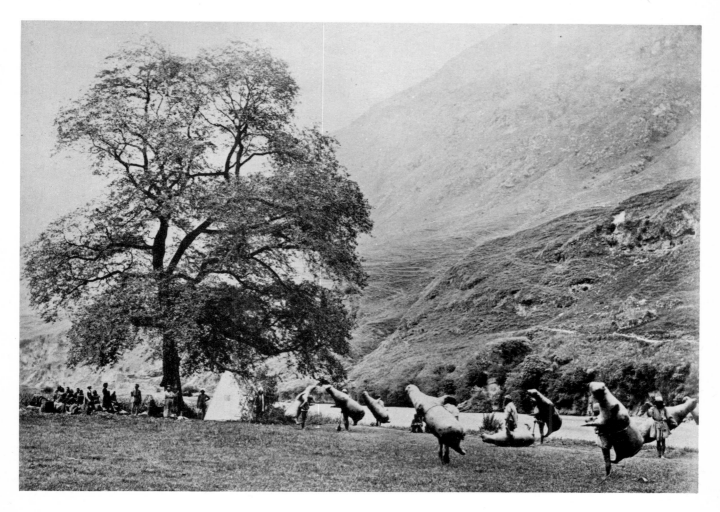

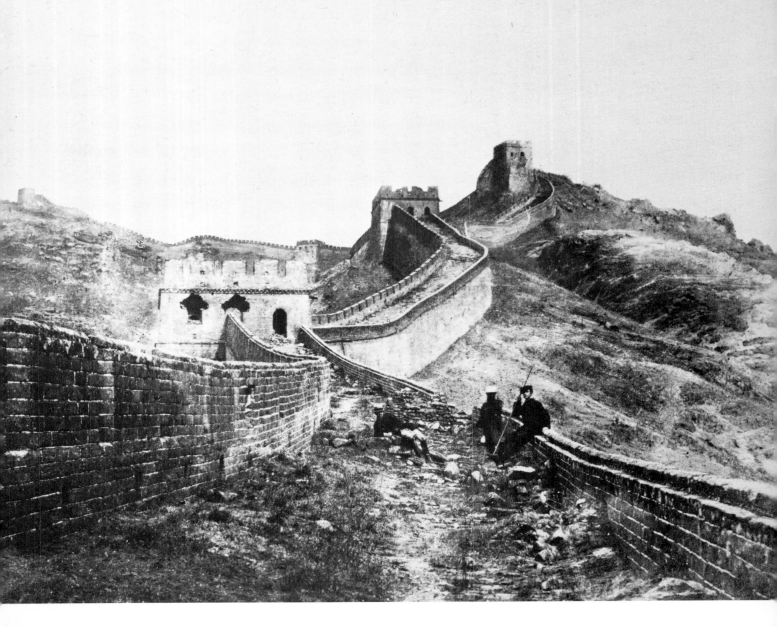

UNKNOWN: *the Great Wall of China, c 1870. This has been attributed to Francis Frith but there is no evidence to suggest he visited China.*

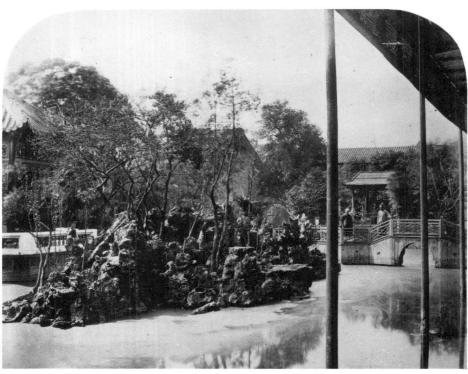

LIEUT. J. A. PAPILLON: *garden in Temple of Longevity, Canton, c 1867. From an album of work by the Amateur Photographic Association.*

FELICE A. BEATO: *Satsuma's Palace, Yedo*, c 1862–7.

These two photographs are two of the many beautiful views that appear in *Photographic Views of Japan* (Yokohama, 1868). Beato went to Japan in 1862 and spent many years there photographing Japanese officials, peasants and ordinary families as well as palaces, towns, temples, and the countryside. He also took extremely fine panoramas, which, like most of his work, are found in albums with Japanese covers. Many of his Japanese photographs possess a strange mystical quality.

FELICE BEATO: *Kamakura*, c 1862–7.

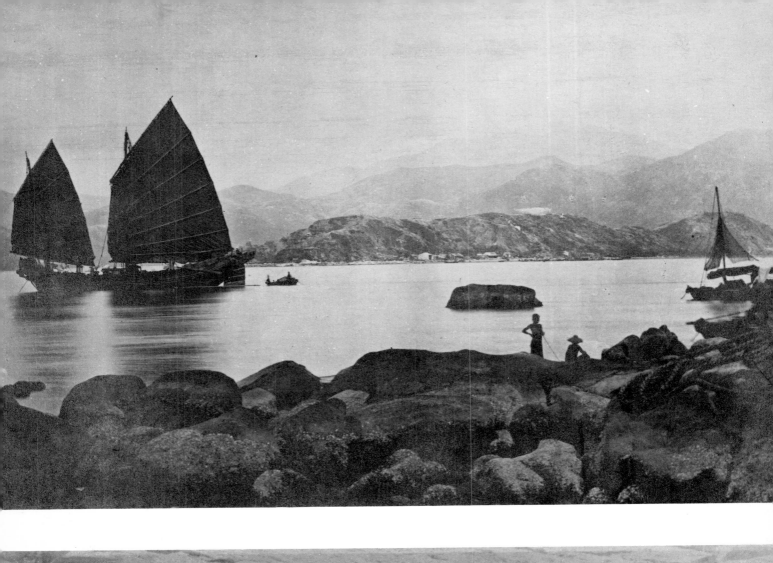

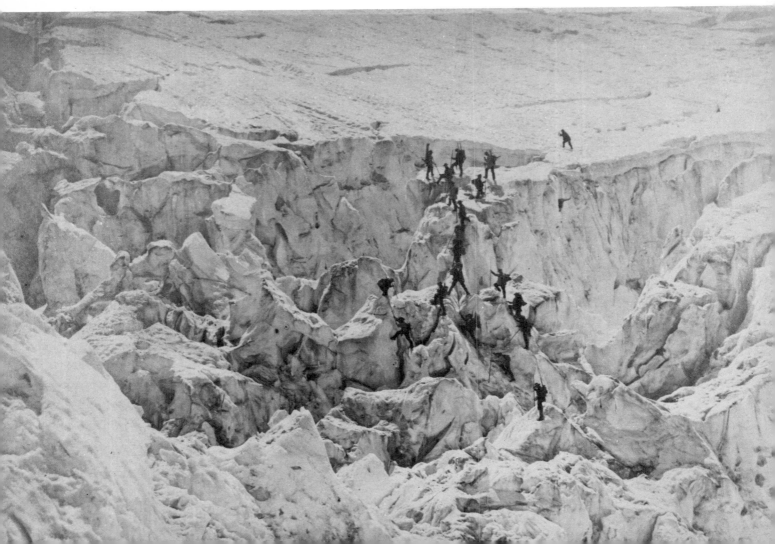

The following is a description given by the photographer:

When a customer enters a shop the proprietor, a grey-headed man perhaps, but conveying by his well-dressed person a profound appearance of old-established honest trading, will slowly and calmly set down his pipe on the polished counter, or push aside his cup of tea, and then inquire, politely the nature of his customer's demands. Should he have the article in stock, he will sell it at the price fixed by the members of the guild to which he belongs, or a higher one if he can obtain it; but should he be discovered underselling his neighbour, he would be subjected to a heavy penalty.[9]

JOHN THOMSON: *Physic Street, Canton, c 1871.*

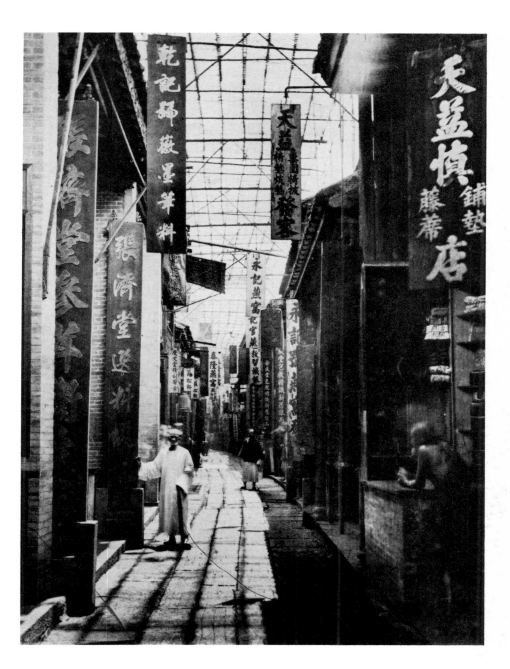

The brothers Louis Auguste and Auguste Rosalie Bisson were well-known Parisian photographers whose most memorable work was done in the French Alps in the early 1860s. The Bisson brothers tried to reach the summit of Mont Blanc in 1860 and although unable to succeed, they brought back a superb collection of views. The following year, Auguste, with twenty-five porters to carry his photographic equipment and supplies, reached the summit and took the first photographs from there.

BISSON FRÈRES: *On the Way Up, 1860 or '61.*

49

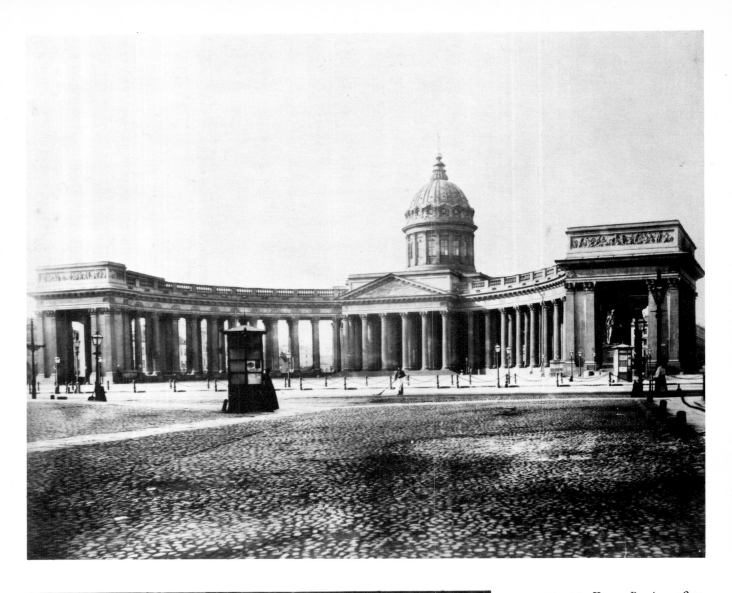

UNKNOWN: *Kasan, Russia* c 1870.

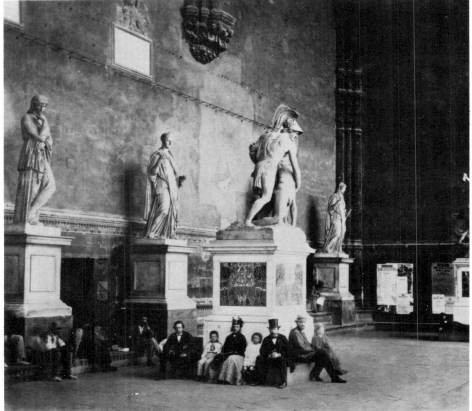

Probably WILLIAM CARLTON
WILLIAMS: *Loggia della Signoria,
Florence,* c 1870.

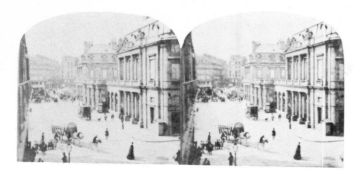
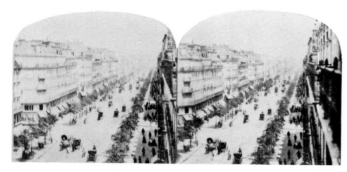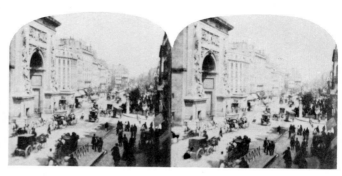

WILLIAM ENGLAND: *instantaneous stereoscopic views of Paris, 1861.*

The importance of the stereoscope in the Victorian home cannot be over-emphasised. Antoine Claudet, the eminent daguerreotypist, described this recreation as follows:

> The stereoscope is the general panorama of the world. It brings to us in the cheapest and most portable form, not only the picture, but the model, in a tangible shape, of all that exists in the various countries of the globe; it introduces us to scenes known only from the imperfect relations of travellers, it leads us before the ruins of antique architecture, illustrating the historical records of former and lost civilizations, the genius, taste, and power of past ages, with which we have become as familiarized as if we had visited them. By our fireside we have the advantage of examining them, without being exposed to the fatigue, privation, and risks of the daring and enterprising artists who, for our gratification and instruction, have traversed lands and seas, crossed rivers and valleys, ascended rocks and mountains with their heavy and cumbersome photographic baggage . . .[10]

William England (d 1896) was one of the first photographers employed by The London Stereoscopic Company. His photographs of Ireland, America, Paris and Switzerland were seen by thousands of people. He joined The Photographic Society in 1863 and served on its council from 1867 until his death.

John Thomson (1837–1921) was one of the most dedicated pioneers in applying photography to travel. In 1865 he sailed from England to the Malay Peninsula and proceeded to Siam and Cambodia. He then went to Macao and Hong Kong, taking photographs by the wet-plate process wherever he went. From Amoy he crossed to Formosa and travelled a considerable distance into the interior. Returning to the coast of China, Thomson visited Fuchow, Chusan, and Shanghai, making frequent visits to the interior and going as far north as Peking. He spent five years in China and the results of his travels were published in four volumes entitled *Illustrations of China and Its People* (1873–4). In 1878 when England had just taken over Cyprus, Thomson photographed on the island and his photographs and accompanying text were published under the title *Through Cyprus with the Camera*

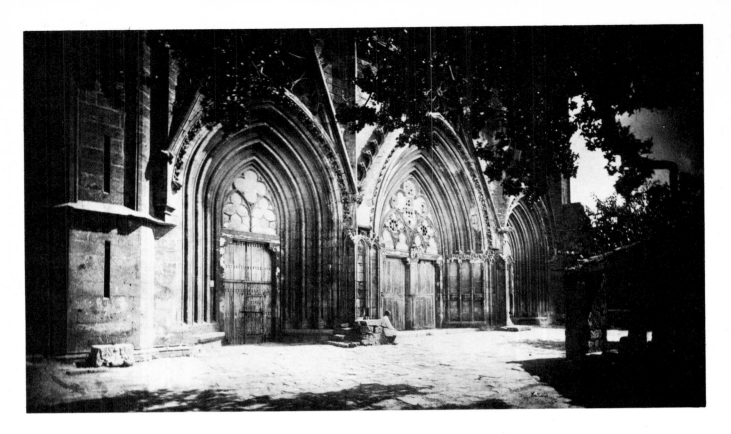

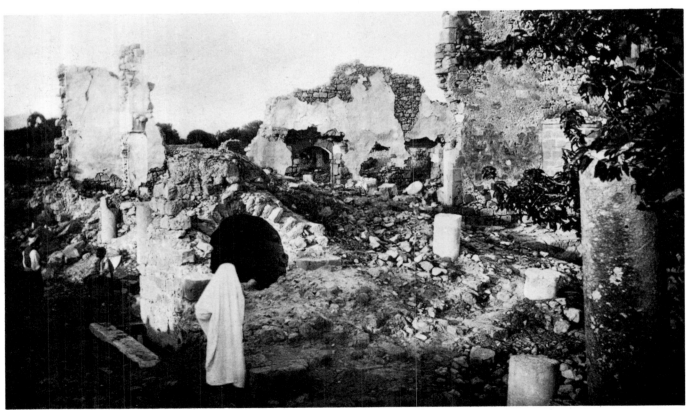

in the *Autumn of 1878* (1879), in two volumes with sixty permanent photographs.

In the introduction of *Through China with a Camera* (1898) Thomson explains why he has always been dedicated to the combination of photography and travel:

> Since the time when I made my first journey into Cambodia to examine its ancient cities, it has been my constant endeavour to show how the explorer may add not only to the interest, but to the permanent value of his work by the use of photography.

JOHN THOMSON. Top: *entrance to the cathedral, Famagosta, Cyprus, 1878*. Bottom: *the ruins of Neo Paphos, Cyprus, 1878.*

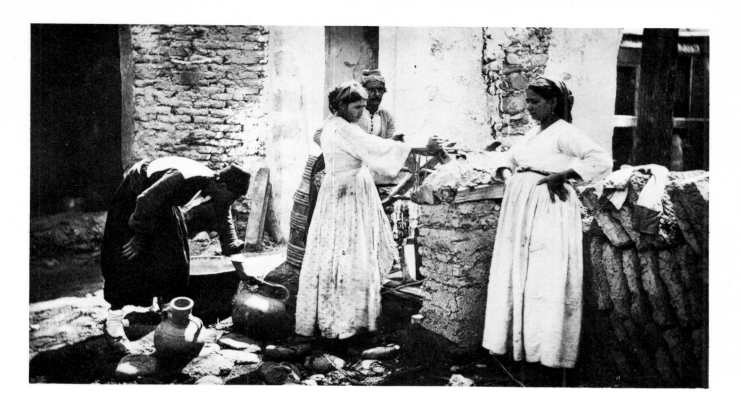

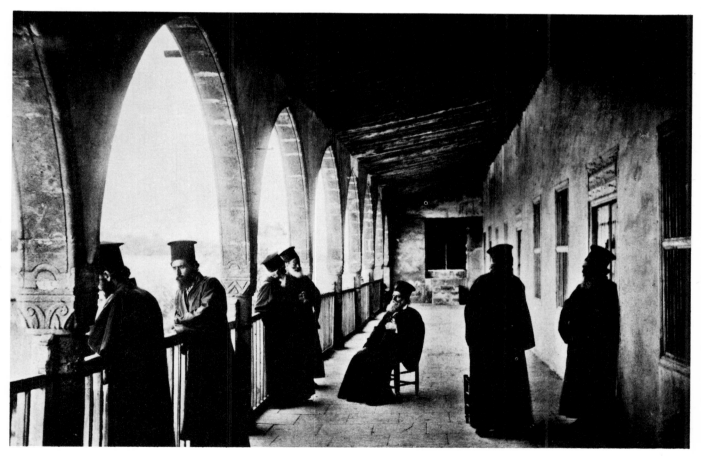

JOHN THOMSON. Top: *women at well, Levka, Cyprus, 1878.* Bottom: *Greek monks, St Pantalemoni, Cyprus, 1878.*

The camera has always been the companion of my travels, and has supplied the only accurate means of portraying objects of interest along my route, and the races with which I came in contact. Thus it came about that I have always been able to furnish readers of my books with incontestable pictorial evidence of my 'bona fides', and to share with them the pleasure experienced in coming face to face for the first time with the scenes and the people of far-off lands . . .

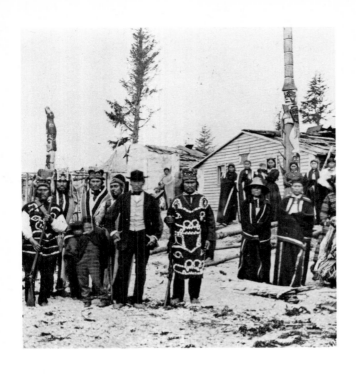

EADWEARD MUYBRIDGE: *probably Warm Spring Indian Camp,* c *1873.*

EADWEARD MUYBRIDGE: *husking coffee, Las Nubes, Guatemala, 1875.*

EADWEARD MUYBRIDGE: *Central America, 1875.*

EADWEARD MUYBRIDGE: *coffee pickers at their ablutions, 1875.*

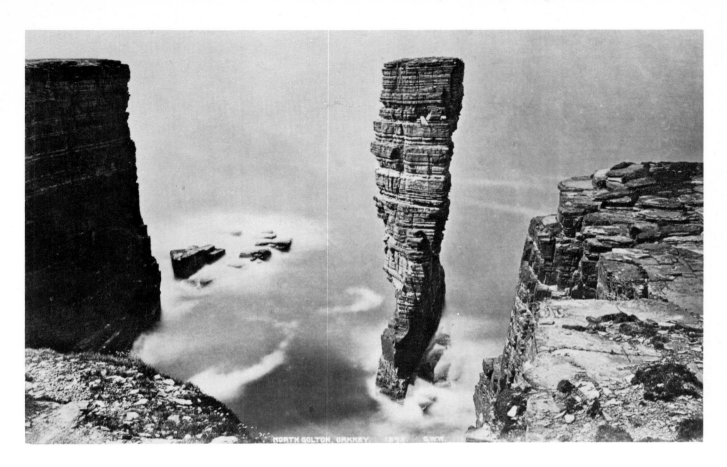

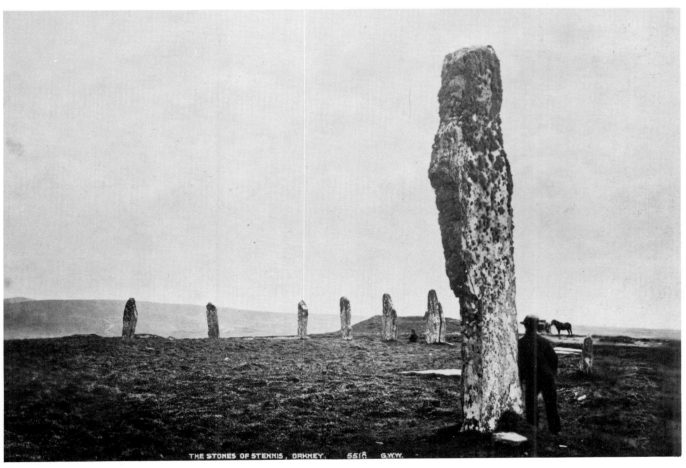

GEORGE WASHINGTON WILSON. Top: *North Golton, Orkney*. Bottom: *the Stones of Stennis, Orkney*.

UNKNOWN: *the Delhi durbar in honour of Queen Victoria becoming Empress of India,*
1877. 'Durbar' is the Persian word for 'a ceremonial gathering of court'.

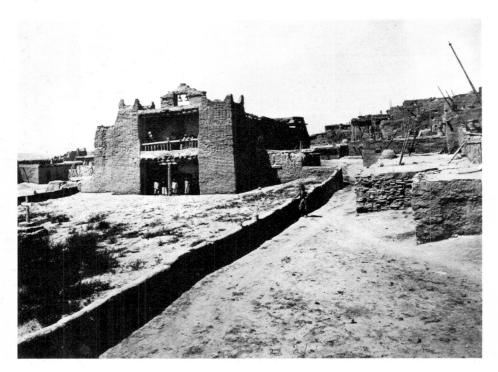

TIMOTHY O'SULLIVAN: *old mission church, New Mexico, 1873.*

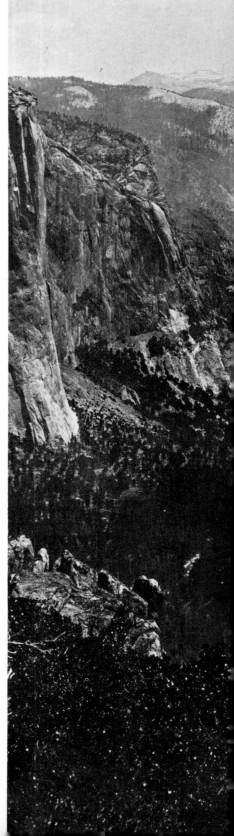

W. H. JACKSON: *Yosemite Valley.*

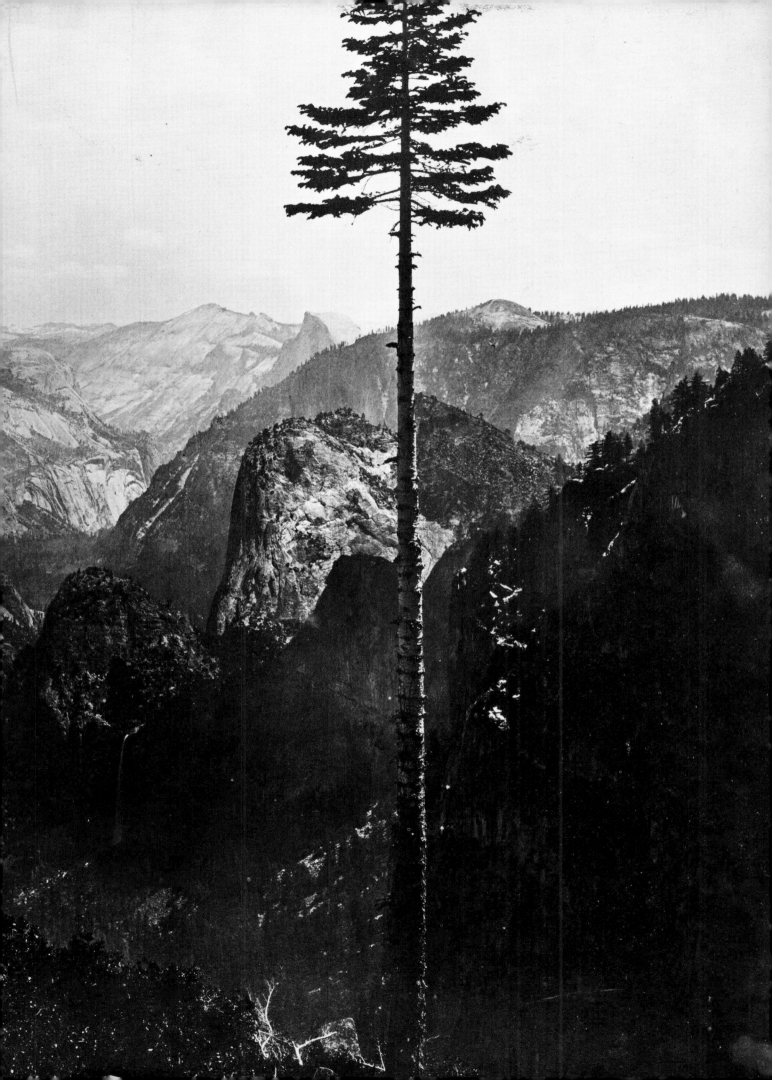

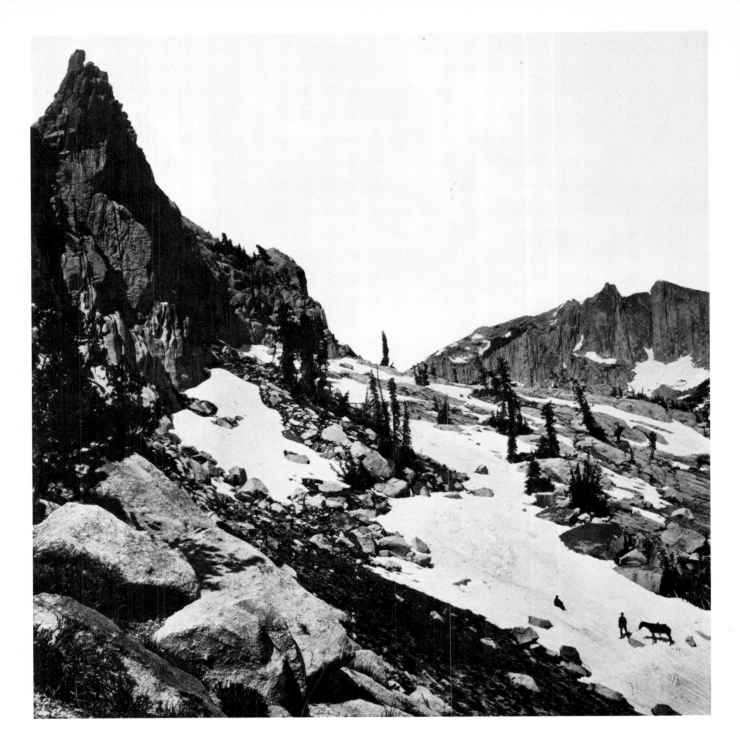

Timothy H. O'Sullivan was probably born in 1840 in New York City. Having learned photography in the New York gallery of Mathew B. Brady, O'Sullivan was one of the leading Civil War photographers. He was employed for over seven years by Alexander Gardner. In 1867 O'Sullivan went to the fortieth parallel on his first of many geological surveys. At Virginia City, Nevada, he photographed hundreds of feet underground in the Comstock Lode mines using magnesium flares. Photographing for Thomas Oliver Selfridge's Darien Expedition, O'Sullivan went to Panama in 1870. The following year he joined First Lieutenant George Montague Wheeler in the Engineer Corps' Geological and Geographical Surveys and Explorations West of the 100th Meridian. Here he took magnificent photographs depicting the grandeur of the south-west part of the United States. Again in 1873 and 1874 O'Sullivan joined Wheeler on surveys of the West. In 1880 he received the appointment of chief photographer to the Treasury Department in Washington DC. On 14 January 1882 O'Sullivan died of tuberculosis.

TIMOTHY O'SULLIVAN: *summit of Wahsatch Range, Utah. Taken in 1867 during the geological exploration of the fortieth parallel.*

3 Recording Conflicts

Excerpt from a letter written in the Crimea by Roger Fenton to William Agnew, 18 and 20 May 1855:

> . . . I make slow progress, though as far as lies in my power no time is lost. I am very anxious to return home, as my interests are suffering in my absence, but I cannot make up my mind to leave until I have secured pictures of the persons and subjects likely to be historically interesting.[1]

Wars and uprisings should not be forgotten. Photographers knew this instinctively; their's was the medium that could record faithfully, and more important, convincingly. Think how much more 'real' the American Revolution of 1776 or the Battle of Waterloo would be to us today if we had photographs depicting the men and events of the confrontations. Photography has greatly enriched our historical awareness by allowing us to 'see' as well as 'know' our past.

Roger Fenton, one of the first photographers to 'cover' a war, faced physical

ROGER FENTON: *cookhouse of the 8th Hussars, 1855.*

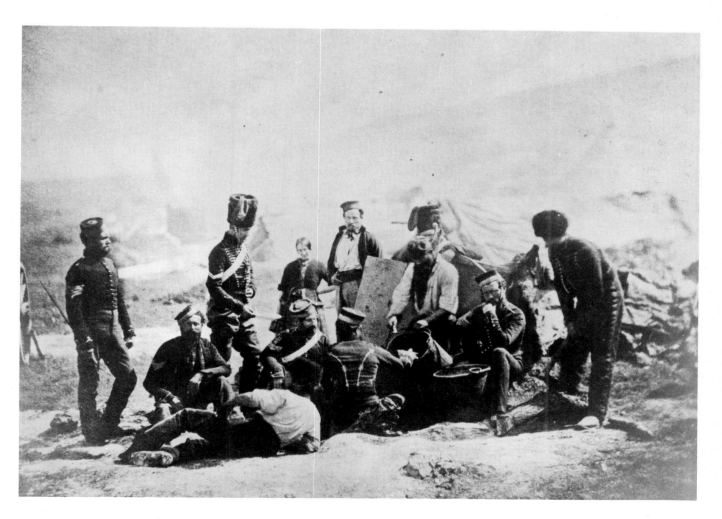

hardships and mental strain in 1855 when he went to photograph the Crimean War. When he first arrived, there may have been a kind of glamour attached to his mission, but he quickly learned of the gruelling realities of the war, and yearned to return home. He had an obligation, he felt, to his countrymen and to posterity and stayed until he became ill.

Roger Fenton arrived in Balaclava on 8 March 1855. His patrons for the expedition were Queen Victoria and Prince Albert. He was financed by the publishers Thomas Agnew & Sons, Manchester, who wanted photographs illustrating the war to sell to the public. Victorian tastes would have been offended had Fenton made photographs showing dead soldiers or the misery and wretchedness of warfare. Fenton, an upper-class Victorian, photographed with 'taste', and showed officers relaxing, scenes of the harbour, the campsites, etc. The officers' uniforms, the soldiers' faces, the paraphernalia in the harbour, the tents, the terrain – all serve to give a greater reality to the documentation of the war. Roger Fenton was a discreet war photographer in what has been described as 'the last of the gentlemen's wars'.

ROGER FENTON: *the photographic van with Sparling on the box, 1855.*

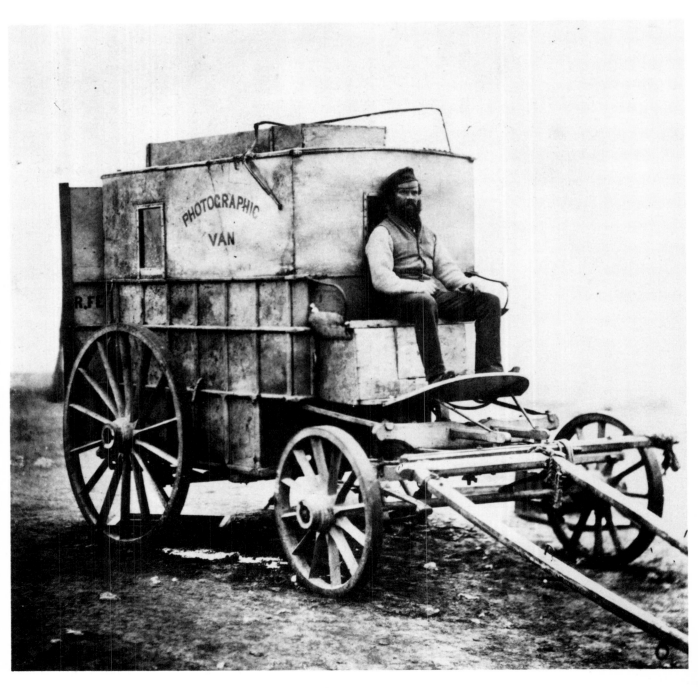

Fenton took two assistants with him to the Crimea: Williams, handyman and cook, and Marcus Sparling (seen in the photograph) as driver and groom. Although both men helped with the photographic work, Fenton alone took the photographs.

The van Fenton brought to the Crimea had originally belonged to a wine merchant and he converted it for sleeping, cooking, dark-room work, etc:

> When it entered into the service of Art, a fresh top was made for it, so as to convert it into a dark room; panes of yellow glass, with shutters, were fixed in the sides; a bed was constructed for it, which folded up into a very small space under the bench at the upper end; round the top were cisterns for distilled and for ordinary water, and a shelf for books. On the sides were places for fixing the gutta-percha baths, glass-dippers, knives, forks, and spoons. The kettle and cups hung from the roof. On the floor, under the trough for receiving waste water, was a frame with holes, in which were fitted the heavier bottles. This frame had at night to be lifted up and placed on the working bench with the cameras, to make room for the bed, the furniture of which was, during the day, contained in the box under the driving-seat.[2]

Between the American Civil War and the Crimean, the Indian Mutiny and the China War were powerfully documented by photographs. It was the American Civil War, however, that provided the most outstanding examples of early war illustration. Credit for the magnificent coverage of this war must go to Mathew B. Brady (1823–96). He was a leading New York portrait photographer who decided at the onset of the war to make a thorough visual record of it. He employed some twenty photographers and invested $100,000 in outfitting and training them. It is Brady's organisational abilities and bravery in the face of grave danger that are so highly respected today. It is very difficult to know which photographs were taken by Brady himself as opposed to those taken by his assistants; Brady put his name to every image taken by his employees.

Alexander Gardner (1821–82) had been in charge of Brady's Washington studio since 1858 and helped him cover the Civil War. He disagreed, however, with his employer's policy of not allowing each photographer to hold the copyright of his own work and broke away from Brady in 1863 to form his own photographic corps. In 1866 he published his *Photographic Sketch Book of the War*, containing 100 illustrations in two volumes. These are some of the strongest images of the American Civil War and each photographer's name is clearly marked.

Mathew Brady, who during the war years was confident that the United States government would purchase his collection of negatives, was proven wrong. His photographs, which showed so clearly the brutality of the bloody war, were not desired by many people after the battles had ended. The government did not purchase the complete set, either, as Brady had hoped. In 1874, unable to pay for the storage of his negatives (one set of negatives already having gone to his main creditors E. & H. T. Anthony & Co), Brady put them up for auction and the United States War Department purchased the collection from the storage company for $2,840. A year later James Garfield, later President Garfield, brought up the matter of payment to Brady in the House of Representatives with the following words:

> Here is a man who has given 25 years of his life . . . to one great purpose – to preserving national monuments so far as photographic art can do so, with a view of making such a collection as nowhere exists in the world . . . This man went so far as to send his organization into the field and some of his men were

wounded in going near the battlefield to take pictures of the fight that was going on.[3]

Although $25,000 was finally voted to Brady, he was too far in debt to be relieved and he died in the poor ward of a New York hospital.

The men who photographed uprisings as distinct from full scale wars, often did so without any personal ambition for fame or financial gain. They felt committed to photograph the violence around them and concerned themselves with recording the results of the fighting that had occurred. (Exposures were too long to capture the acts themselves.) Many of the photographs, therefore, of the Paris Commune of 1871 and the aftermath of the Indian Mutiny are anonymous.

After Fenton's trip to the Crimea, photographers had a new area of responsibility. Photography was not just an enjoyable pastime, art, or means of portraiture – it had a place in current affairs and its practitioners felt a commitment to record any crisis that might arise. By 1878 the *Photographic News* reported that: 'Photography is recognised to such a degree in our army, that no preparations would be considered complete unless every requisite of the art was at hand.'[4]

In February 1848, revolution broke out in Paris forcing Louis-Philippe to abdicate. After heavy fighting between 23 and 26 June, a liberal constitution was adopted based on common suffrage, and parliamentary government. Louis-Napoleon's nephew was elected President.

Hippolyte Bayard (1801–87) was an independent inventor of photography. He exhibited examples of his prints in June 1839 before details of the daguerreotype process were revealed. His own process needed a very long exposure (about an

HIPPOLYTE BAYARD: *the remains of the barricades of the revolution of 1848, rue Royale, 1849.*

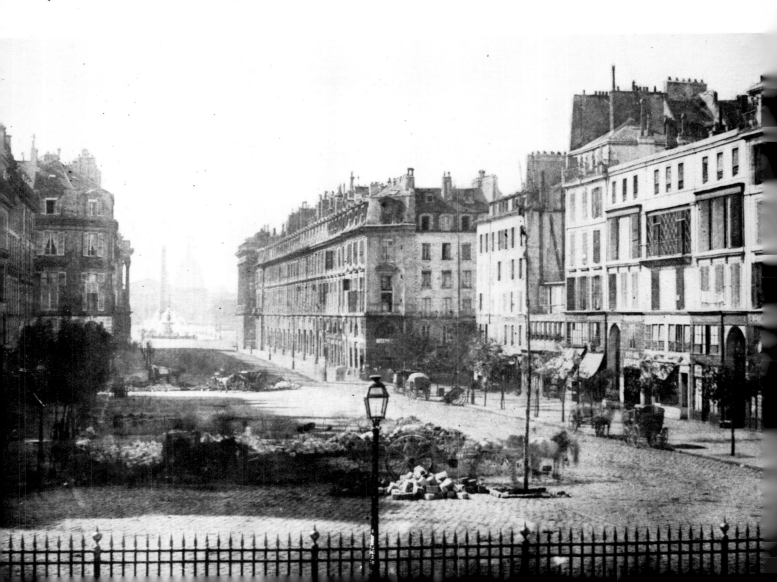

hour) and produced a direct positive on paper; there was no negative. Bayard's photographs display great artistic beauty and sensibility. He was a master photographer and his studies on paper done by his own and Talbot's processes (which he used for his later work) are delicate and highly personal images. He was one of the best, yet least appreciated, of the early photographers.

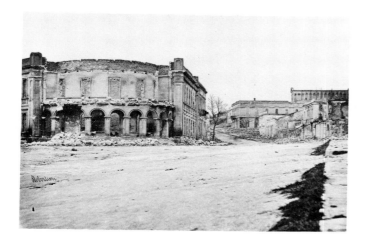

JAMES ROBERTSON. Above: *theatre, Sebastopol, 1856.* Above right: *tower of the Malakoff, 1856.*

In 1853 Russia attempted to annexe Turkish territory. Napoleon III was anxious to go to war as a matter of prestige and England feared that the Russian expansion would interfere with her lines of communication to India. In mid-September, 1854, British and French troops numbering some 57,000 arrived on the Crimean peninsula with the hope of taking Sebastopol, the Russian naval base. Allied with them were Turkish and Sardinian troops. The war carried on until 30 March 1856 when the peace treaty was signed in Paris.

James Robertson arrived in the Crimea shortly before the fall of Sebastopol and his photographs form a continuation of Roger Fenton's work, the latter having left the Crimea on 30 March 1856. Robertson was superintendent and chief engraver of the Imperial Mint at Constantinople and an enthusiastic photographer. His images of the war show the result of the siege of Sebastopol which marked the beginning of the end of the war. His views of the Redan and the Malakoff are powerful records of the aftermath of terrible battles. Robertson also captured the atmosphere of the ruined city of Sebastopol (see above photograph), the docks and the forts; sites where so much activity had just recently taken place.

Another Englishman who photographed the Crimean War was George Shaw Lefevre (later Baron Eversley), but his photographs are quite undistinguished. More interesting are the panoramas of Jean Charles Langlois, a Frenchman, who came to the Crimea at the end of 1855 and stayed four months.

Credit for being the first photographer to report the Crimean War must go to Carol Popp de Szathmari. A Romanian born in Transylvania in 1812, Szathmari was court-painter and photographer to one of the Romanian dukes. After 1830 he lived in Bucharest where he died in 1887.

Szahmari first appeared in the Crimea, laden with his photographic apparatus, in April 1854. Through friendly connections he had access to the two Russian and Turkish camps on the banks of the Danube. He photographed the battle scenes, the Russian generals, the Cossacks, and the Turkish Pasha. Eventually he was able to compile a photo-album with 200 pictures. At the beginning of 1855 albums of his photographs were given to the French Emperor Napoleon III, Queen Victoria, and the Emperor Franz Joseph of Austria. The Duke of Saxe-Weimar was given one by his friend the pianist Liszt, and another Szathmari album was on view at the Universal Exhibition of 1855 in Paris.[5] Unfortunately

none of these albums exist today and it is through lack of visual evidence of his war photography that the name of Carol Popp de Szathmari has become almost obscure.

Felice A. Beato was Venetian by birth and a naturalised British subject. Beato met James Robertson in Malta in 1850 and they began a close association. They first photographed in Malta in calotype and they travelled to Egypt and Athens using wet-collodion apparatus. When Robertson returned from the Crimea he joined Beato who was on his way to India to photograph the uprising. On their way they stopped in Palestine to take some views. [6]

After the Indian Mutiny, Beato joined the Anglo-French campaign against China and was able to photograph some of the major events at the end of the Opium War. In 1862 Beato went to Japan.

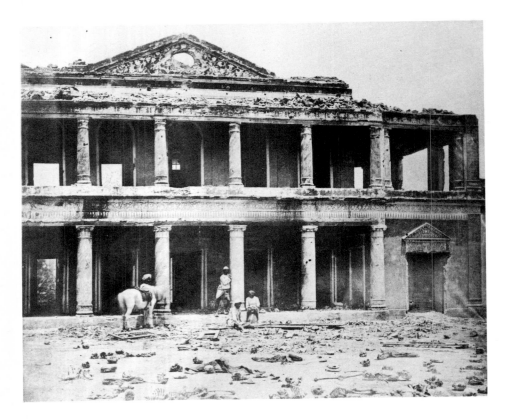

FELICE BEATO: *Secundra Bagh, Lucknow, 1858. 1,860 of the mutinous sepoys were cut down by the 93rd Regiment and Sikhs, and though their corpses were interred the dogs later dug them up (explanation by an eyewitness, Colonel F. C. Maude, VC).*

The Indian Mutiny of 1857 began when the Bengal army mutinied at Meerut. The uprising was an attempt to stop the activities of the East India Company and to assure the survival of Indian civilisation.

For many years the Indian population had felt resentment and anxiety towards the British. The immediate cause of the mutiny was the introduction of the new Enfield rifle which used a cartridge supposedly lubricated with both cows' and pigs' fat. This was odious to both the Hindu, for whom the cow was sacred, and to the Moslem who considered the pig unclean. The East India Company removed the cartridge and arrested eighty-five of the sepoys who had refused to use it. The next day three regiments at Meerut mutinied, shot their officers, released their comrades, and set off for Delhi.

The Mutiny took eighteen months to be halted completely. At the beginning there were very few British troops available in India – indeed it took two months before news of the Mutiny reached England. Sir Colin Campbell was appointed Commander-in-Chief and set sail for India with troops to put down the Indian

revolt. Already towns like Lucknow and Meerut were held by the sepoys. It was not until March 1858 that Campbell, accompanied by 30,000 men, took the Secundra Bagh, the last sepoy stronghold. The existing photographs of the Mutiny give proof of the violence displayed on both sides.

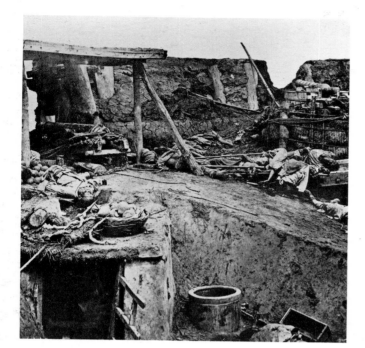

FELICE BEATO: *North Taku Fort after a fight, 1860 (detail)*.

FELICE BEATO: *Pehtang Fort with captured wooden guns, c 1860 (detail)*.

Initially British interest in China was focused on the East India Company's need to buy tea at Canton for re-export. The most lucrative Indian commodity to exchange was opium. The Imperial government of China banned the drug in 1800 but large scale smuggling continued. The importation of opium into China by foreign traders led to the war of 1839–42 between Great Britain and China. It also was the cause of the second China War (1856–60) between China and Great Britain and her ally, France.

In June 1857, the British destroyed the Chinese fleet and six months later the British and French fleets took Canton and sailed towards Peking. The Taku forts which protected the entrance to Tientsin were captured in May 1858. The Chinese, in order to save Peking, agreed to a treaty forced upon them permitting the importation of opium, travel to inland China, foreign diplomats living in Peking, tolerance of Christianity, payment of indemnities and freedom of trade. It was not, however, until 1860 that China ratified the peace treaty after much bloodshed on both sides.

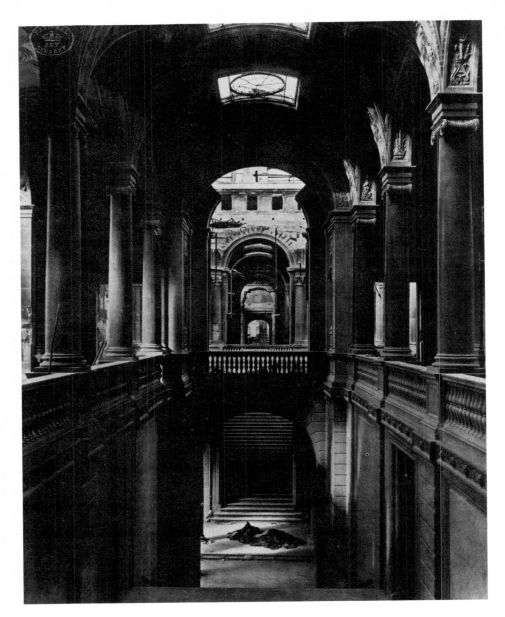

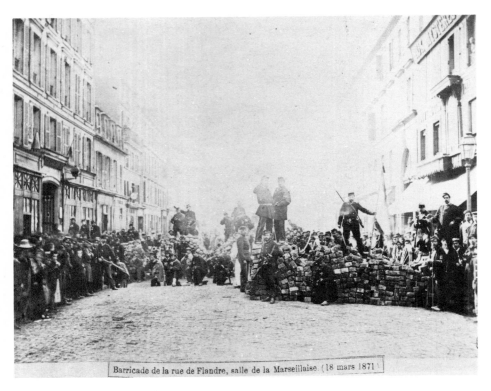

Barricade de la rue de Flandre, salle de la Marseillaise (18 mars 1871)

66

The Paris Commune lasted seventy-two days, from 18 March to 28 May 1871. It was marked by the courage and fortitude of the people of Paris. Although the government of Versailles had capitulated to the Prussians after the Franco-Prussian War (1870–1), the Parisians would not surrender their city to the foreign invaders. The negotiations that had been concluded between the Prussians and the French government had been either for France to give Belfort to Germany, or to allow 30,000 men of the victorious Prussian army to occupy a part of Paris until the National Assembly ratified the peace plans. These arrangements were obviously horrendous to the Parisians and they defended their city with great fearlessness and determination until they were defeated by the superior strength of Adolphe Thiers, the head of the French Royalist Government, and his men.

It was on the 18 March that Thiers with his soldiers tried to recapture Montmartre and to take away the arms from the insurgents. The whole hill was held by the troops but while the generals were waiting to advance, prostitutes and housewives infiltrated the ranks and proposed that the soldiers should drink with them. When General Lecomte, representing the National Assembly, called upon his men to open fire, his troops hesitated and reversed their rifles. The crowd rushed forward embracing the soldiers and took them to the wine counters of Montmartre. General Lecomte was taken prisoner and later Clément Thomas, who in June 1848 had ordered a 'charge on the scum', was also seized. Both were executed. There are no words to describe the terror that prevailed during the uprising. The Commune massacred 480 people. Thiers and his men massacred 20,000.

UNKNOWN: *One of the barricades erected by the communards during the Paris Commune, 1871.*

The second Afghan War (1878–80) broached the problem of whether or not Britain should take the border of India to the Kabul–Ghazni–Kandahar line. Kandahar was a position of strategic importance dominating the whole of southern Afghanistan. One of the main reasons why Britain wanted to occupy Afghanistan was the prevailing philosophy that it would constitute the advancement of civilisation and the substitution of law and order for misrule and tyranny. There was also the question of prestige, and in Asia, a strong country should never retreat.

Naturally there was an attempt on the part of the British government to justify the retention of Kandahar on financial grounds, saying that the riches of the city would make it a revenue-producing district. In reality if Britain occupied Kandahar, she would also have to occupy other areas and in doing so need to defend a totally unreasonable frontier which ran along the foothills of wild, mountainous country. The decision of how much of Afghanistan to occupy was never resolved, as the Conservatives were defeated in the general election of 1880, and the Liberal administration which came to power was fiercely opposed to prior Conservative policy on the Afghan question.

J. Burke was a professional photographer in the Punjab. He was frequently employed by the government of India to accompany British and Indian troops when they went into battle. The conditions under which he served the government as 'photographic artist' were as follows: Burke would receive a set sum of money, local honorary rank, free carriage (about twelve mules), rations for himself and servants and a horse on payment. He would supply his own apparatus, chemicals and other requirements. The government, on the other hand, was entitled to Burke's services whenever required. The government would receive six copies of each photograph and had the option to purchase any or all of the plates at a set valuation, Burke retaining duplicates of all the negatives.[7]

In March 1879 the government wrote to Burke asking him if he would accompany the 1st Division Peshawar Valley Field Force while they were fighting in Afghanistan. Burke was eager to do so and immediately replied in the affirmative outlining the conditions under which he would serve. Although in the past these conditions had been acceptable to the government, they were not now. Burke, who had been expecting a favourable response set off to join the forces before receiving an answer. He was concerned that if he waited any longer he would miss the advance. Once he finally received the government's letter, he made plans to return to India. It is possible, however, that many of his fine photographs of the Afghan War would not have been taken had he not been so impetuous.

J. BURKE: *officers of Her Majesty's 51st Regiment on Sultan Tarra, showing different service uniforms worn, c 1879.*

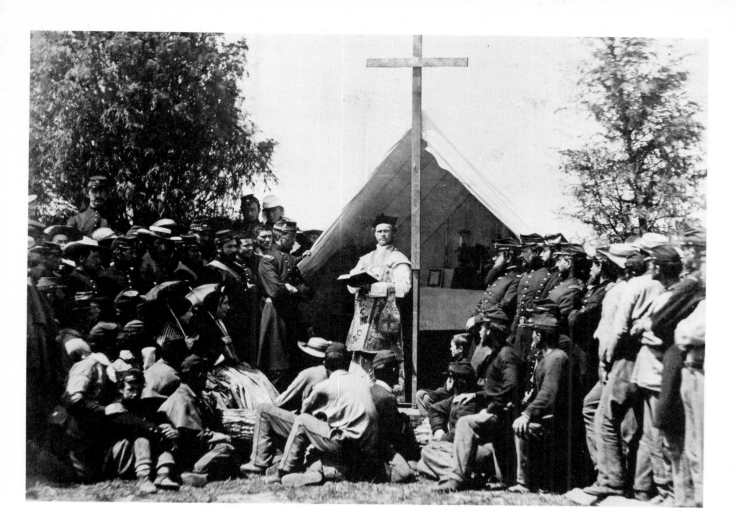

UNKNOWN: *Sunday morning Mass in camp of the 69th New York State Militia, Arlington, Virginia, May 1861.*

The American Civil War lasted four years, from 12 April 1861 until 9 April 1865. It was one of the bloodiest wars Americans ever fought and resulted in the deaths of over 617,000 individuals.

Six weeks after Abraham Lincoln was elected President of the United States on an anti-slavery platform, South Carolina seceded from the Union. Soon afterwards ten other Southern states joined with South Carolina in forming a new country called the Confederate States of America. Lincoln refused to recognise the right of any state to secede from the Union and sent troops to occupy Fort Sumter in Charleston Harbour, South Carolina. The Confederates, having deep grievances of both a sociological and economic nature, opened fire on the fort, thus beginning the war between the states.

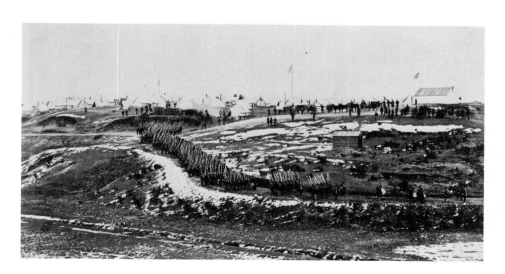

UNKNOWN: *drilling troops near Washington* DC, *1861.*

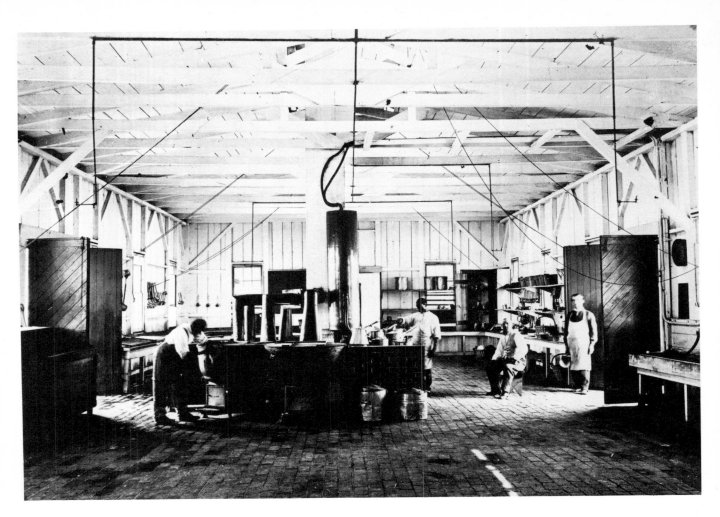

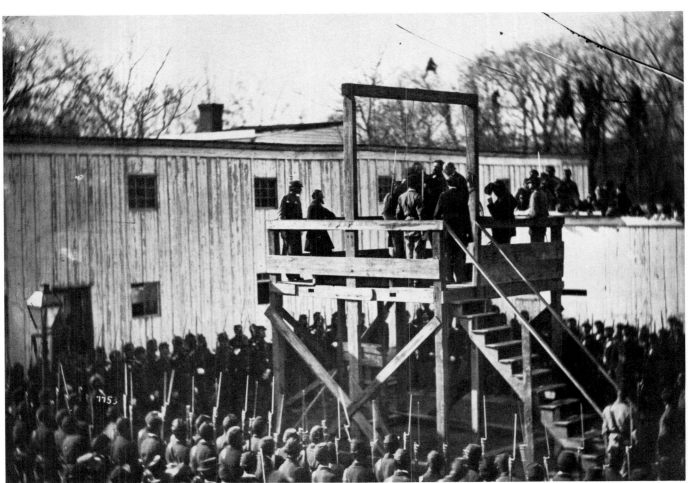

UNKNOWN: *kitchen of Soldier's Rest, Alexandria, Virginia, July 1865.*

JOHN REEKIE: *a burial party, Cold Harbor, Virginia, April 1865.*

The leading field photographers of the American Civil War were Alexander Gardner, George N. Barnard, John F. Gibson, and Timothy O'Sullivan.

Alexander Gardner was the first United States photographer to receive an official military appointment. When he parted from Brady in 1862 he went to work for General George B. McClellan as 'Photographer on the Potomac'. His official duties lay in multiplying maps and documents; his views of the war were done independently.

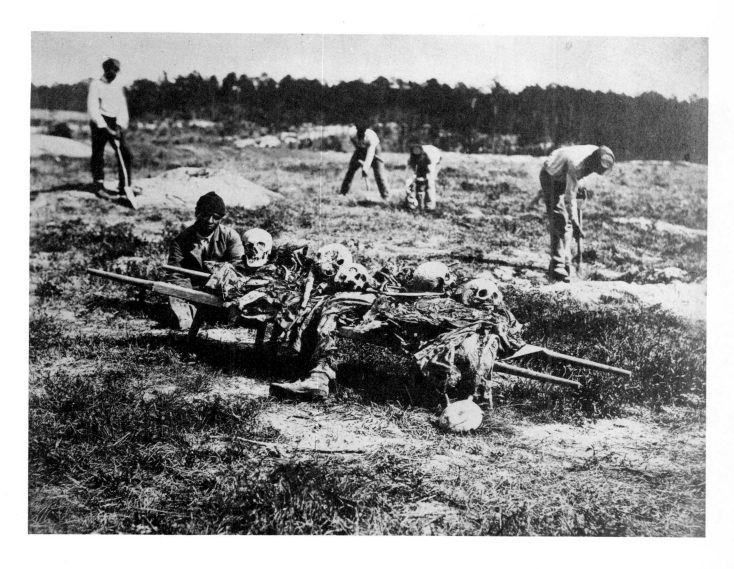

Over page (*pp* 72 and 73). Probably ALEXANDER GARDNER: *ruins on the canal basin, Richmond, Virginia, 1865.*

ALEXANDER GARDNER: *Execution of Captain Henry Wirtz, CSA in Washington DC (adjusting the rope), 10 November 1865.*

'This sad scene represents the soldiers in the act of collecting the remains of their comrades, killed at the battles of Gaines' Mill and Cold Harbor. It speaks ill of the residents of that part of Virginia, that they allowed even the remains of those they considered enemies, to decay unnoticed where they fell. The soldiers, to whom commonly falls the task of burying the dead, may possibly have been called away before the task was completed. At such times the native dwellers of the neighborhood would usually come forward and provide sepulture for such as had been left uncovered. Cold Harbor, however, was not the only place where Union men were left unburied. It was so upon the field of the first Bull Run battle, where the rebel army was encamped for six months afterwards. Perhaps like the people of Gettysburg, they wanted to know first 'who was to pay them for it.' After that battle, the soldiers hastened in pursuit of the retiring columns of Lee, leaving a large number of the dead unburied. The Gettysburgers were loud in their complaints, and indignantly made the above quoted inquiry as to the remuneration, upon being told they must finish the burial rites themselves.'[8]

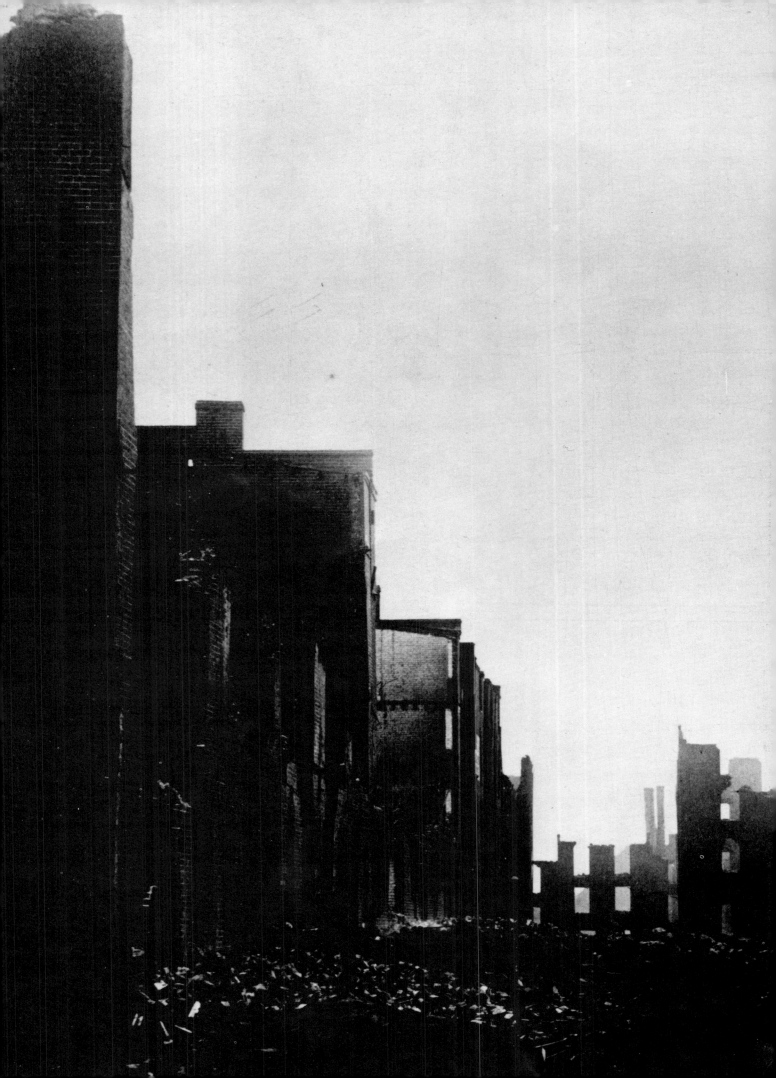

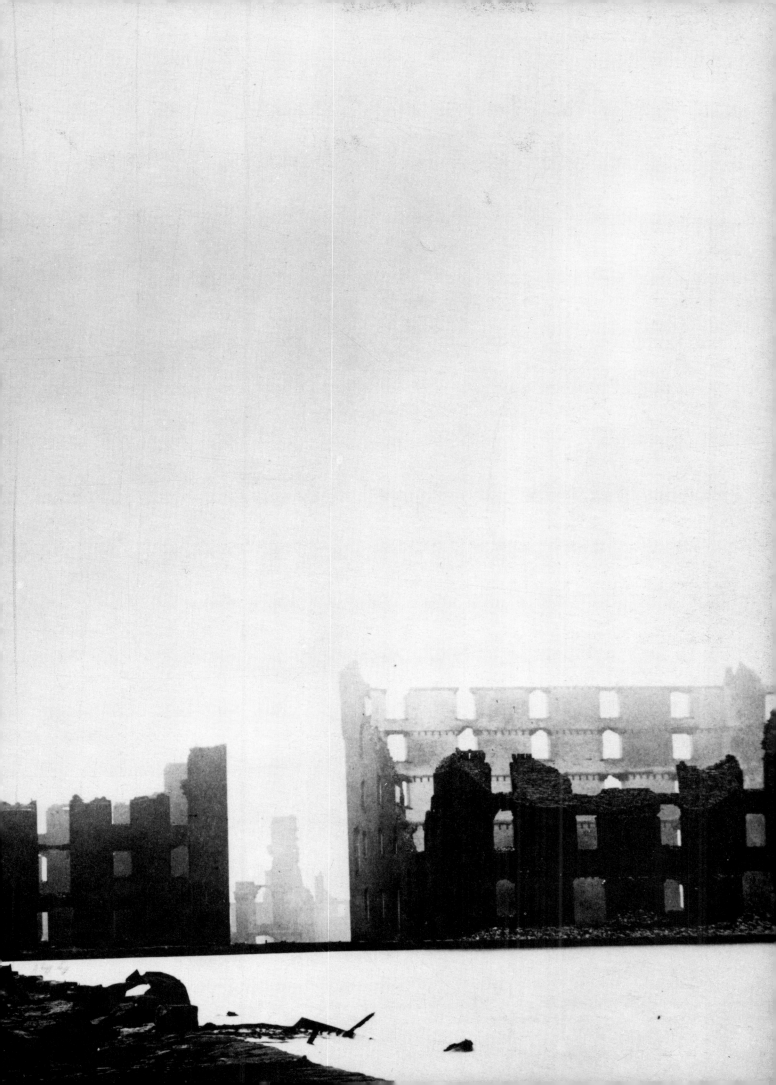

4 Emergence of a Social Awareness

The photographic image is a powerful means of arousing emotions and making people aware of a particular situation. It is difficult to know exactly when photography was first used as a tool for the correction of certain social ills. It is easier to find out when photography was first used to record different social groups and professions. William Henry Fox Talbot photographed the workmen around Lacock Abbey, Wiltshire, but this in itself does not imply that Talbot saw himself as a sociologist with a camera. Photography was too new a medium, and Talbot was experimenting with the range of subjects the camera could deal with, and not with what the image itself could say.

Some of the earliest examples of photographs that make a strong social comment are the photographs of Crimean War casualties. Whether or not the photographer (who might have been J. E. Mayall) intended his photographs to be a cry against the brutality of war is unknown. It is hard to believe, however, that the photographer was unaware of the emotional effect his photographs would have on the

Probably w. h. f. talbot: *workman at Lacock, Wiltshire, c 1844.*

DR HUGH W. DIAMOND: *mental patient, c 1852–6. Dr Diamond exhibited his photographs of mental patients from 1852–8 and they aroused much attention. Several of Dr Diamond's photographs were shown at the International Exhibition in Paris, 1855.*

DR HUGH W. DIAMOND: *mental patient, c 1852–5.*

viewer. On page 82 there is the photograph of three handsome men in their prime of life, all fearfully maimed. There is also the photograph of Sergeant Dawson of the Grenadier Guards (see page 83) unable to hug his daughter with two arms, one having been lost in the Crimea.

Dr Hugh Welch Diamond (1809–86) was a great humanitarian and a very early worker in the field of photography. He is one of the few photographers whose name appears in the *Dictionary of National Biography*. He is listed there principally for work he did in the field of mental disease. From 1848 to 1858 he was resident superintentendent of female patients at Surrey County Asylum, and in 1858 he established a private asylum for female patients at Twickenham, where he lived.

Between 1858 and 1868 Dr Diamond was secretary of The Photographic Society and edited its journal for many years. He combined his two interests and was probably the first person to apply photography to the direct treatment of mental patients.

Dr Diamond read a paper to the Royal Society titled 'On the Application of Photography to the Physiognomic and Mental Phenomena of Insanity'. The paper was reviewed in the *Saturday Review*, 24 May 1856 and reprinted in the *Photographic Journal*, 21 July 1856, pp 88–9. Excerpts of the review of Dr Diamond's paper are as follows:

The object of the paper is to show the peculiar application of photography to the delineation of insanity. The investigation of the various phenomena of this sad affliction must ever be highly interesting. The metaphysician and moralist, the physician and physiologist, will approach such a inquiry with their peculiar views, definitions, and classifications. The photographer, on the other hand, needs, in many cases, no aid from any language but his own—preferring rather to listen, with the picture before him, to the silent but telling language of nature.

An asylum for lunatics on a large scale supplies instances of delirium with raving fury and spitefulness—of delirium accompanied with an appearance of gaiety and pleasure in some cases, and with constant dejection and despondency in others—or of imbecility of all the faculties, with a stupid look, and general weakness. The photographer catches in a moment the permanent cloud, or the passing storm of sunshine of the soul, and thus enables the metaphysician to witness and trace out the connexion between the visible and the invisible in one important brand of his researches into the philosophy of the human mind. Raving madness is generally accompanied by the forehead being contracted, the eyebrows drawn up, the hair bristled, and the eyeballs prominent, as if they were pushed out of their orbits. Photography, as is evident from the portraits which the author exhibited in illustration of his paper, confirms and extends this description, and to such a degree as to warrant the conclusion that the permanent records thus furnished are at once the most concise and the most comprehensive.

There is another point of view in which the value of portraits of the insane is peculiarly marked, viz in the effect which they produce upon the patients themselves. In very many cases they are examined with much pleasure and interest, but more particularly when they mark the progress and cure of a severe attack of mental aberration.

Dr Diamond also realised that if each patient was photographed before leaving the hospital, they could be quickly identified if they were ever re-admitted. To recognise the face of a patient is often a better reminder to the doctor of the case in question than the actual written description on the patient's record.

A group of photographers who had a strong social conscience were the men who photographed the American Civil War. War is one of man's greatest social problems

and war photographs also have a place in this chapter. The photographs of the slave-pens in Virginia (see pages 85), however, seem to have no *raison d'être* other than as a social comment on man's capacity for cruelty. The pen does not look fit for an animal – the photographer states this forcefully in his photograph.

Not all social comments are necessarily negative. Frank Meadow Sutcliffe (1853–1941) photographed English rural life with delicacy and warmth. He had deep admiration for country people who earned their livelihood from the land and from the sea. Sutcliffe's photographs depict their strength, solemnity and humour. He described his way of working as follows:

> When photographing rustic figures out of doors, I think the best plan is to quietly watch your subjects as they are working or playing, or whatever they are doing, and when you see a nice arrangement to say 'Keep still just as you are a quarter of a minute,' and expose, instead of placing an arm here and a foot there, which is sure to make your subject constrained, and consequently stiff. To be able to wait and watch, you will want a plate that will keep moist at least a quarter of an hour. This may easily be done by using old collodion and, in hot weather, also sponging the inside of the dark slide, making it quite wet. [1]

Sutcliffe was born in Leeds, Yorkshire, on 6 October 1853. His father Tom was a painter as well as an etcher, lithographer, and photographer. The Sutcliffe family moved to Whitby, Yorkshire in 1871. Frank Sutcliffe did not take up photography until after his father's death (12 December 1871), although Tom had for some time encouraged his son to make it a career. After Sutcliffe's marriage to Eliza Duck and unsuccessful attempts to find a studio in Whitby, he and his wife went to Tunbridge Wells, Kent. As there were already a number of professional photographers there at the time, business was poor and in 1875 Sutcliffe returned to Whitby. This time he was able to find a place that he could convert into a studio and soon established himself as a professional portrait photographer. His fine reputation which gradually developed around the world was, however, as a landscape and 'genre' photographer.

Sutcliffe used wet-plates up until the 1880s. Later in his photographic career when techniques such as soft focus were popular, he still maintained that photography should not disguise itself and lose its essential qualities of exactitude, gradation of tone, etc.

Sutcliffe was an energetic, passionate photographer. He loved the photographic medium, people, and the countryside. When he finally retired from photography in 1923, he was asked by the Council of the Whitby Literary and Philosophical Society to become curator of the Whitby Gallery and Museum. He held this post from the age of seventy to eighty-seven. Frank Sutcliffe died on 31 March 1941.

Probably the first man to use photography in public relations work was also one of the greatest child-care workers in Victorian England. Dr Barnardo, the man who saved homeless children from a life of great distress, also realised that the sad faces of these little outcasts could be used to raise money for their food, clothing, and accommodation. Dr Barnardo started using photography in 1870, and, for publicity, packets of photographs were sold with the following description:

> Three Deeply Interesting Packets of Photographs, marked respectively A, B, and C, Price five shillings each packet (either sent post-free). Packet A contains Twenty Photographs of isolated cases. Packet B is made up entirely of Contrasts, illustrating and comparing the past and present conditions of Destitute Lads received into the Home. Twenty photographs. Packet C also contains Twenty Photographs of which fourteen exhibit contrasts between the past and present conditions of certain Boys, and the remaining six illustrate other general features of the work. Each Packet is complete in itself. Friends desiring to purchase one only should indicate their choice when ordering.

Dr Barnardo's and thousands of other organisations are still using photography today to arouse public awareness. In 1874 Dr Barnardo spent £250 out of a budget of £11,500 on photography, a clear indication of the importance it played in his work.

A discussion of early social documentary photography would not possibly be complete without mentioning the Victorian photographer John Thomson (whose work also appears in chapter 2). He was co-author of one of the classic works of the period on social reform – *Street Life in London*. With text by Adolphe Smith and photographs by Thomson, the work appeared in monthly editions beginning in February 1877. Priced at 1s 6d per copy, each issue portrayed the life of the working class in London. *Street Life in London* was a breakthrough in photographic reporting and observation. In mid-Victorian times photographers did not point their cameras at overt social problems. Perhaps this fact in itself reflected something of the period—social conditions of the working classes were not something to be looked at either with the naked eye or the camera.

Thomson had shown concern for people's living conditions for many years. Prior to *Street Life in London* knowledge of his photography is limited to his work in Asia, where he travelled largely with the view of 'utilizing photography to record the characteristic features of the countries and people of the Far East'. As with all travelling photographers the recording of social conditions are only one of many concerns. The traveller to foreign lands is often too influenced by local customs, landscape, climate, food, etc, to be able to look objectively at isolated social conditions. When Thomson photographed in his own city of London, where he had a professional photographic studio, he was able to do it with the skill of an experienced photographer, and with the keen perception of one who knows the locale well.

This chapter shows the first stages in the development of the photographer as eye-witness to the state and condition of society. Although in the beginning the photographer did not understand the power that lay in a documentary photograph, he soon learned about its ability to effect emotions and bring about change. The early social documentary photographs possess a kind of innocence and lack of pretention. They are a refreshing change from the sophistication and cunning of the present day propaganda photograph. The best work, however, of today's photo-journalists, is very much a reflection of the concerns and honesty of approach of the early photographers.

D. O. HILL and R. ADAMSON: *the Royal Society of Arts Concert, 1843; the three musicians are Linley, Loder, and Dragonetti, on double bass and two cellos.*

David Octavius Hill (1802–70) was a well-known book illustrator and landscape artist. In 1843 he decided to do a large painting commemorating the establishment of the Free Church of Scotland. To aid him in the painting of the 400 or so ministers present, Hill decided to use photography. In 1843 he became partners with Robert Adamson (1821–48) who had learned the technique of photography from his brother John who in his turn had learned it from Sir David Brewster. Between 1843 and 1848 they produced about 1,500 calotype portraits, mainly of Scottish notables, which are cherished today for their remarkable use of light, texture, and tone and for the strength of character brought out in the faces of the sitters.

In June 1845 Hill and Adamson photographed fisherfolk in Newhaven, near Edinburgh. Possibly they took the photographs in the hope of issuing them for sale, the profits going to the fisherfolk to help them get their boats decked for safety. Like all Hill's publishing ideas for using calotypes, this project came to nothing.

D. O. HILL and ROBERT ADAMSON. Above left: *Newhaven fisherman, June 1845*. Above: *the Reporters' Table, General Assembly of the Free Church, Glasgow, 1843*. The news reporters were not posed, so perhaps this is totally Robert Adamson's creation. It is difficult to see the role D. O. Hill would have played in making this image.

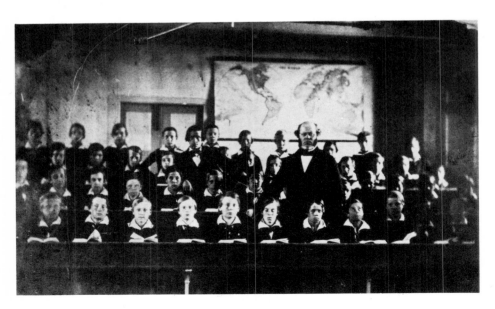

UNKNOWN: *the Greenwich Hospital School, c 1860*.

78

Thomas Annan was born in 1830, the son of a miller in Dairsie, Fife. Against his father's advice, he apprenticed himself to a lithographer and soon became an excellent free-hand copperplate engraver. Annan was friendly with a young doctor Berwick who was interested in chemistry and the development of photography. His enthusiasm was passed on to Annan and together they set up a photographic business in Glasgow in 1855. Berwick soon left and Annan stayed for two years before moving to a new address. In 1859 Thomas Annan established photographic printing works at Burnbank Road, Hamilton. Next door lived David Livingstone's sisters and when Livingstone returned from Africa in 1864, Annan became very friendly with him and took the well-known portraits of the missionary-explorer.

Robert Annan, Thomas's brother, was considered a partner in the business and was responsible for administration. By 1877 Thomas Annan's two sons, John and James Craig (the outstanding portrait photographer), were also involved in the photographic studio. The house of T. & R. Annan and Sons Ltd was well known for its reproductions of works of art and Thomas was a pioneer in carbon printing. In his later life he was engaged in photo-engraving in association with Sir Joseph Wilson Swan. Thomas Annan died in 1888.

Between 1868 and 1877 Thomas Annan photographed in and around slum areas for the Glasgow City Improvement Trust. His documentation is an outstanding example of the use of the camera as a social weapon. Although many of the photographs do not have people in them, Annan realised the impact the picture would have if there was a person peering out of a doorway, in a passageway, or in a close. Annan's photographs convey a kind of sadness – the sadness that people had to live in such appalling conditions. These photographs linger in one's mind, for they show a reality that only the camera could preserve.

THOMAS ANNAN: *no 11 Bridge-gate, Glasgow, 1867.*

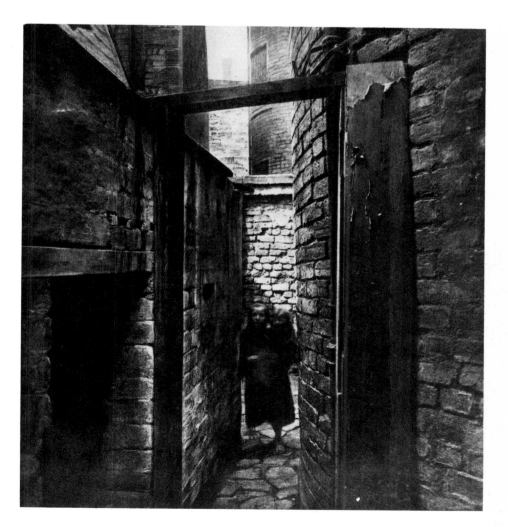

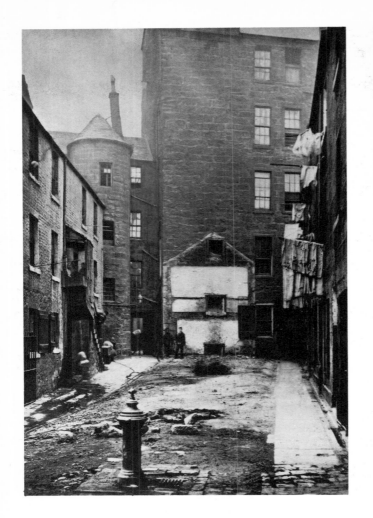

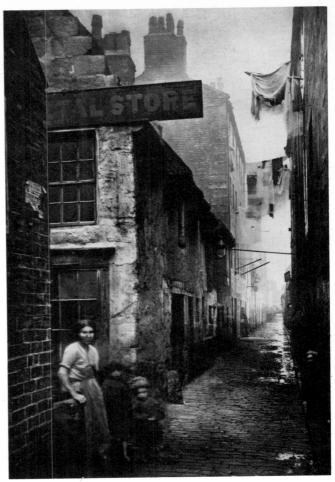

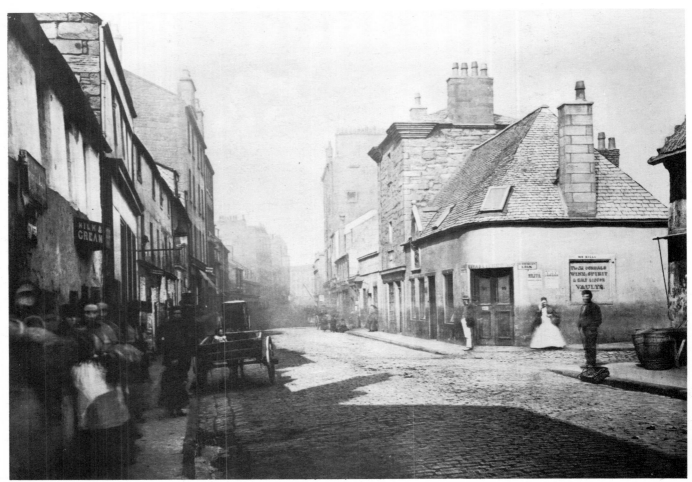

THOMAS ANNAN. Far left: *closes 97 and 103 Saltmarket, Glasgow, 1868.* Left: *Old Vennel off High Street, Glasgow, 1868.*

THOMAS ANNAN: *Main Street, Gorbals, looking north, 1868. Copied from* The Old Closes and Streets of Glasgow, *illustrated with fifty photogravure plates by Annan from his photographs taken for the City of Glasgow Improvement Trust, between 1868 and 1899, with an introduction by William Young, R.S.W.*

CHARLES NÈGRE: *the little tinker, c 1852.*

Charles Nègre was an exceptionally fine documentary photographer. Born in Grasse, he photographed mostly in the surrounding areas. In 1860 Nègre was ordered by Napoleon III to make a photographic report of the Imperial Asylum at Vincennes, a charitable institution for the care of disabled workmen. By using small plates and a relatively wide lens, Nègre was able to overcome the poor lighting and make photographs with great impact and delicacy.

81

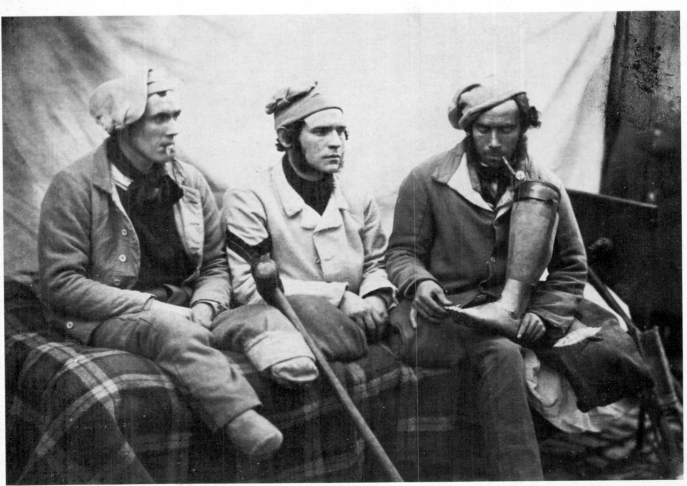

CHARLES NÈGRE: *chimney sweeps, Quai Bourbon, 1852.*

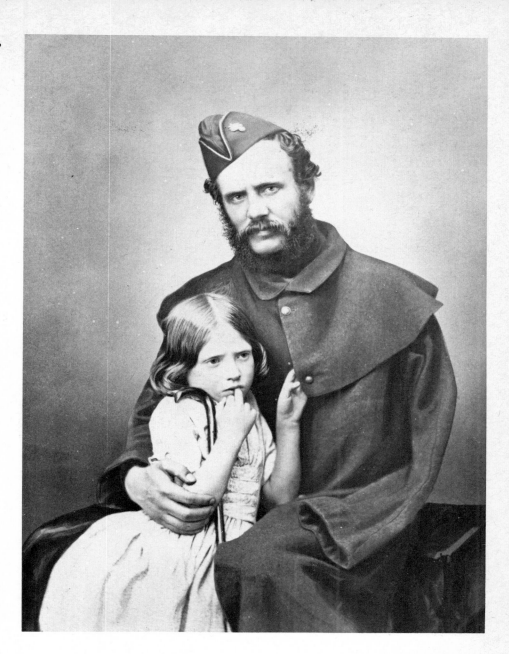

Probably J. E. MAYALL: *Sergeant Dawson, Grenadier Guards, who was wounded in the Crimean War,* c 1856.

UNKNOWN: *wounded soldiers from the Crimea seen by Queen Victoria at Chatham, Kent,* c 1856.

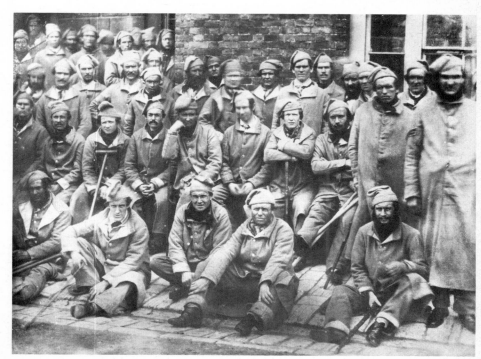

UNKNOWN. Left to right: *William Young, Henry Burland, and John Connery. Crimean War casualties seen by Queen Victoria when she visited Chatham, Kent,* c 1856.

In the introduction to *The Expression of the Emotions in Man and Animals* Darwin explains his reasons for beginning this investigation:

'. . . when I read Sir C. Bell's great work, his view, that man had been created with certain muscles specially adapted for the expression of his feelings, struck me as unsatisfactory. It seemed probable that the habit of expressing our feelings by certain movements, though now rendered innate, had been in some manner gradually acquired. But to discover how such habits had been aquired was perplexing in no small degree. The whole subject had to be viewed under a new aspect, and each expression demanded a rational explanation . . .'

It is interesting to note that Darwin believed sufficiently in the power of photographs to convey human expressions that he used them to support and illustrate his scientific conclusions.

The photographs in the book were taken by O. G. Rejlander (1813–75), a Swede who had trained as a painter in Rome. He learned photography in 1853 from Fox Talbot's assistant Nikolaas Henneman who had a studio in London. He earned his living by taking portraits and nude studies for artists, and is best known for his large allegorical work composed of over thirty negatives titled 'The Two Ways of Life' 1857. Rejlander and members of his family posed for some of the photographs in Darwin's book. Rejlander died a pauper.

O. G. REJLANDER: *plate 2 from* The Expression of the Emotions in Man and Animals *by Charles Darwin, London; John Murray, 1872.*

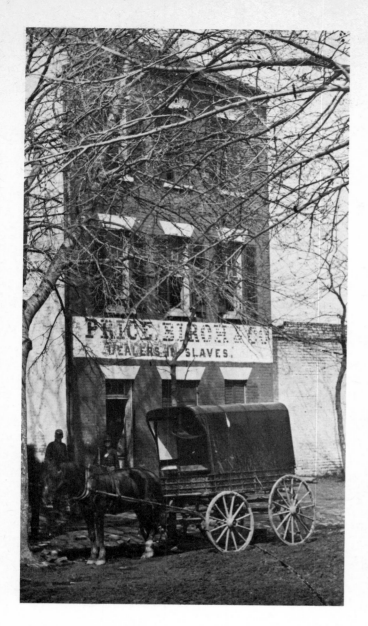

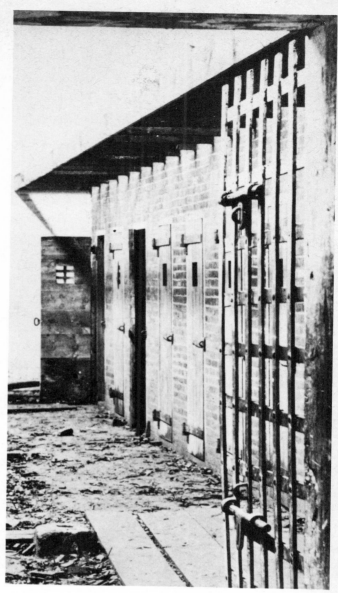

UNKNOWN. Above: *slave pen, Alexandria, Virginia, probably the winter of 1861 or 1862 (detail)*. Above right: *slave pen, Alexandria, Virginia, c 1865 (detail)*.

'In many of the Southern cities the people had erected buildings of this kind for the confinement of slaves awaiting sale. The establishment represented in the photograph was situated in the Western suburbs of Alexandria, near the depot of the Orange and Alexandria Railway. The main building was used by the clerks of the firm and the overseers. The high brick wall enclosed a courtyard, in which were stables and outhouses for the accommodation of planters who come in for the purpose of selling or purchasing slaves. The large building on the right was used for the confinement of the negroes. It had a number of apartments, in which the slaves could be kept singly or in gangs, and one large mess room, where they received their food. The establishment was essentially a prison. The doors were very strong, and were secured by large locks and bolts. Iron bars were fixed in the masonry of the windows, and manacles were frequently placed on the limbs of those suspected of designs for escape. Auction sales were regularly held, at which Virginia farmers disposed of their servants to cotton and sugar planters from the Gulf States. If a slave-owner needed money which he could not easily procure, he sold one of his slaves; and the threat of being sent South was constantly held over the servants as security for faithful labor and good behavior. Before the war, a child three years old, would sell, in Alexandria, for about 50 dollars, and an able-bodied man at from 1,000 to 1,800 dollars. A woman would bring from 500 to 1,500 dollars, according to her age and personal attractions.'[2]

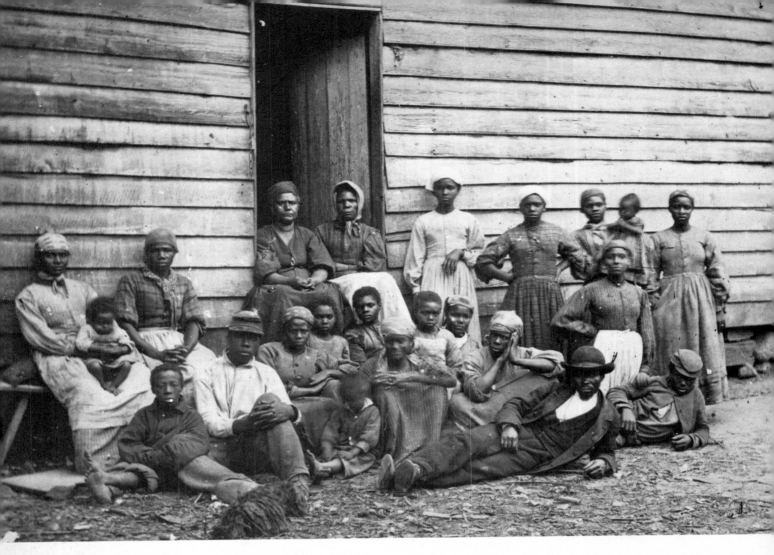

J. F. GIBSON: *Cumberland Landing, Virginia; contrabands on Mr Foller's farm, 14 May 1862. Gibson was a Civil War photographer on Mathew Brady's staff.*

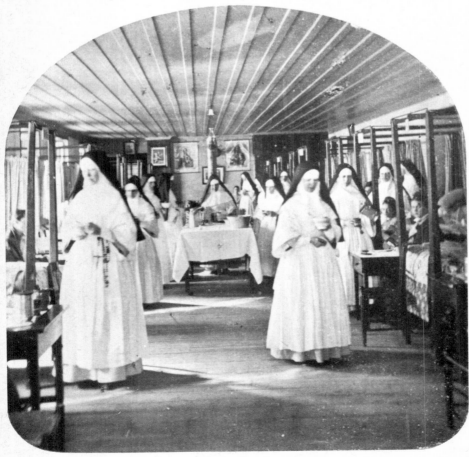

L. P. VALLÉE: *convalescent ward, Hôtel-Dieu, Quebec, c 1875.*

R. LE GRICE: *market woman, Aix la Chapelle,* c 1874: *from an album of photographs by the Amateur Photographic Association.*

'It is indeed a different nature that speaks to the camera from the one which addresses the eye; different above all in the sense that instead of a space worked through by a human consciousness there appears one which is affected unconsciously . . . Photography with its various aids (lenses, enlargements) can reveal this [the indescribable] moment. Photography makes aware for the first time the optical unconscious, just as psychoanalysis discloses the instinctual unconscious.'[3]

HUMPHREY LLOYD HIME: *Letitia – a Cree half-breed, 1858.*

Humphrey Lloyd Hime (1833–1903) was born in Ireland and emigrated to Canada in 1854. He is considered to be one of Canada's finest early documentary photographers.

In 1858 photography was used for the first time in Canada in conjunction with an exploring expedition. The expedition was the Assiniboine and Saskatchewan Exploring Expedition led by Henry Youle Hind, M A, F R G S, Professor of Chemistry and Geology at Trinity College, Toronto, and the photographer was H. L. Hime.

In 1860 Hime published a portfolio of thirty prints of which the following is one. In the series he tried to depict the 'native races' of Canada. He used the wet-plate process and had to load his chemicals, dark tent, camera, tripod, etc, onto a canoe, dog cariole, and Red River cart when he went photographing.[4]

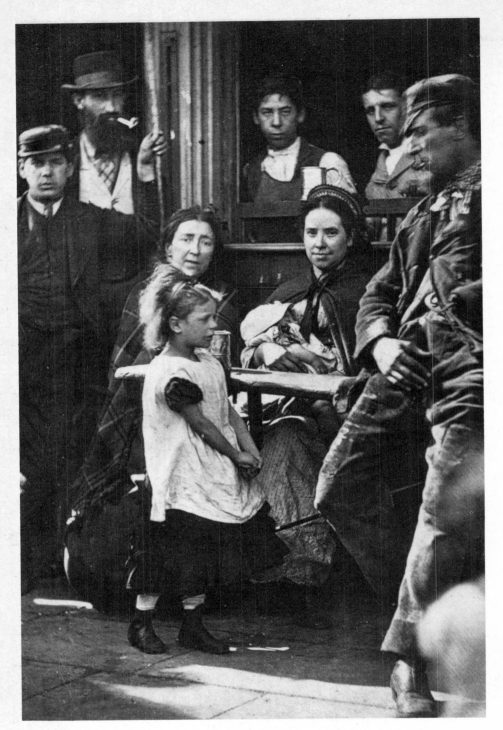

W. W. HOOPER: *famine objects, Madras Famine, 1876–8. Willough-by Wallace Hooper was born in Kennington, Surrey on 4 February 1837. He served with the Madras Light Cavalry from 1858 until his retirement in 1896. He died in 1912.*

JOHN THOMSON: *'Hookey Alf' of Whitechapel,* c 1876.

'The most remarkable figure in this group is that of "Ted Coally", or "Hookey Alf", as he is called according to circumstances . . . While high up on an iron ladder near the canal, at the Whitechapel coal wharfs, he twisted himself round to speak to some one below, lost his balance and fell heavily to the ground. Hastily conveyed to the London Hospital, it was discovered that he had broken his right wrist and his left arm. The latter limb was so seriously injured that amputation was unavoidable, and when Ted Coally reappeared in Whitechapel society, a hook had replaced his lost arm. Thus crippled, he was no longer fit for regular work of any description [he was already epileptic from a previous accident], and having by that time lost his father, the family soon found themselves reduced to want.'[6]

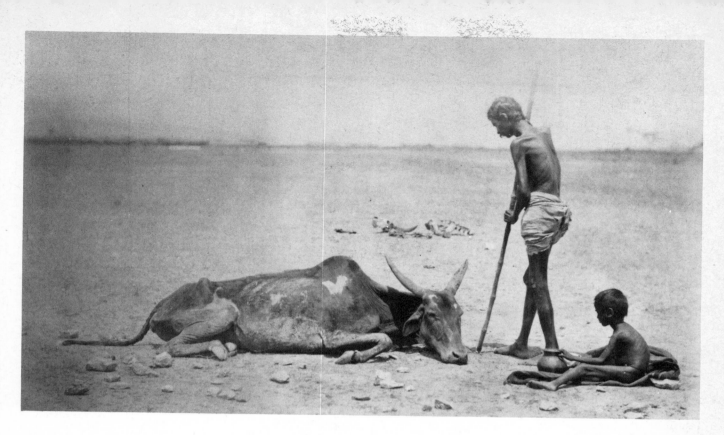

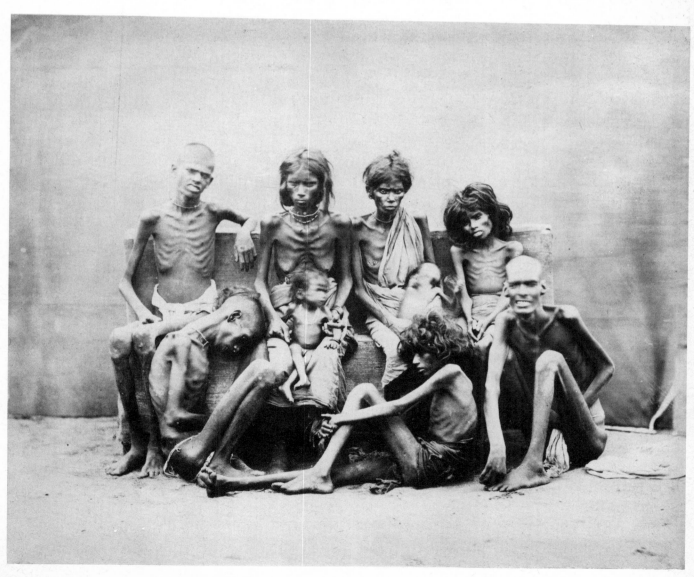

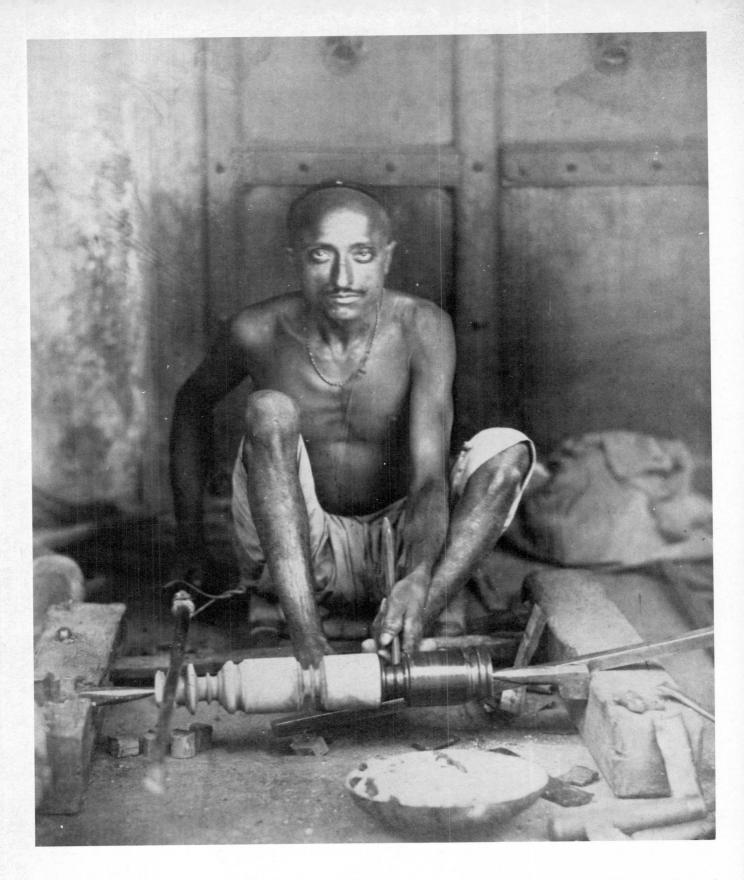

The above and following photograph are from a volume titled *Trades and Occupations* in the India Record Office, London. The volume is one of many albums showing aspects of Indian life. During Victorian times there was great interest shown among the British people towards handicrafts, trades, customs, etc, of foreign peoples. These volumes were quite possibly compiled to send to the large international exhibitions that were held (i.e. the London exhibitions of 1862 and 1872) to give a visual description of Indian life.

UNKNOWN: *lacquer worker and turner, India c 1860.*

UNKNOWN: *Maratti barber*, c
1873.

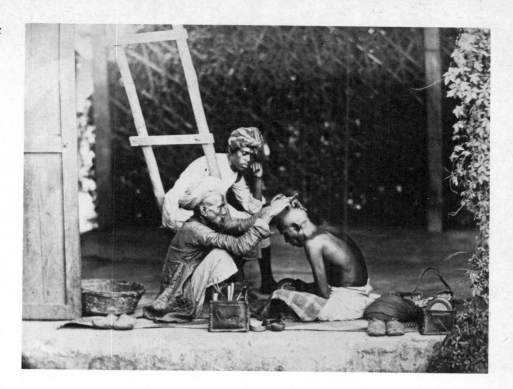

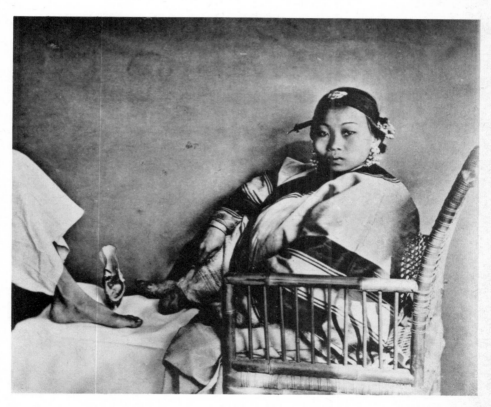

JOHN THOMSON: *small feet of
Chinese ladies*, c *1870*.

'. . . I had been assured by Chinamen that it would be impossible for me, by the
offer of any sum of money, to get a Chinese woman to unbandage her foot . . .
Accordingly, all my efforts failed until I reached Amoy, and there with the aid of
a liberal minded Chinaman, I at last got this lady privately conveyed to me, in
order that her foot might be photographed. She came escorted by an old woman,
whom also I had to bribe handsomely before she would agree to countenance an
act of such gross indecency as the unbandaging the foot of her charge. And yet,
had I been able, I would rather have avoided the spectacle, for the compressed
foot, which is figuratively supposed to represent a lily, has a very different appear-
ance and odour from the most sacred of flowers.'[7]

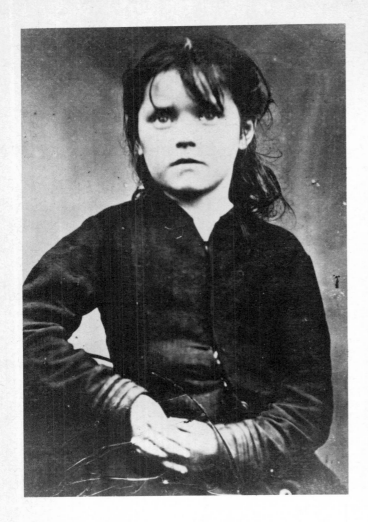

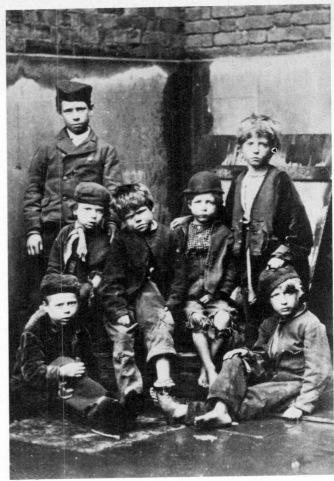

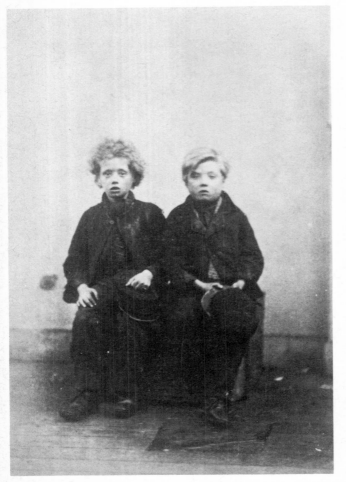

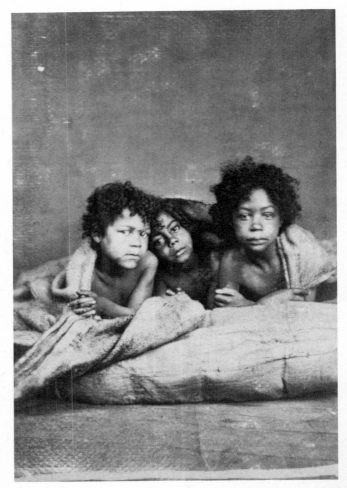

Far left: *Sarah Burge, 5 January 1883.* Left: *the brothers Corrie, the three Kings, Brown and Woodruff, 12 May 1875.* Bottom left: *Henry and William Corr, 17 October 1877.* Bottom right: *the Williams boys, 14 August 1875.*

ALFRED TUCKER.

GOVERNOR'S REPORT

On the date of Boy's admission.

———————

Both his father and mother are alive, and live at No. 104, Heath Street, Commercial Road East. The father is a sailmaker by trade, but at present out of employment. He has five children, three boys and two girls, the former aged 16, 13 and 9, the latter 6 and 4 years respectively. The boy has on several occasions been turned out of doors by his parents. Our beadle saw him sitting on the door steps in the morning, having been refused admittance. He has been working for his bread at a fish curers in Ford Road, Commercial Road, sleeping in barrels in the yards, and the salt from which has contracted a skin disease. Both his parents refuse to have anything more to do with him. They say he is lazy, and old enough to get his own living. They rent two rooms, paying 4/6 per week. The other children are very ragged and poor.

Subsequent Report.

He was selected and sent to Mr. Dawn, smack owner, Grimsby, for service, February 5th, 1876.

23.1.76. A. Tucker came to the Home today & said he was getting on nicely in his place and his master Mr. Dawn had sent him to see whether he could take two boys back to Grimsby with him to be employed by the same master, he stated that he was apprenticed for seven years, but could leave as soon as he was 21 if he wished

29 June 1885
Has been engaged as assistant to the steward by Capt Travers of S.S. Tartar of the Union S.S. Co. Southampton. He will receive at first £1 per month & board.

UNKNOWN: *case history, Dr Barnardo's Homes.*

Upon arrival at Dr Barnardo's each child would have its photograph taken. Ideally a photograph would also be taken of the child when he or she left the home.

A photograph like the one of the Williams boys (see page 92) was often the type used by Dr Barnardo for publicity. The photographer has tried to reconstruct the conditions under which the boys were found.

Admitted *January 5th,* 1876.

Aged 16 Years.

Height, 4-ft. 11-in.

Color of { Hair, Dark Brown.
 { Eyes, Brown.

Complexion, Dark.

Marks on body—None.

If Vaccinated—Right Arm.

If ever been in a Reformatory or Industrial School ? No.

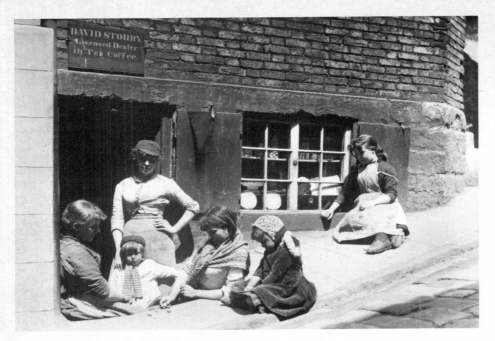

Top. FRANK M. SUTCLIFFE: group of children and women outside a shop at foot of 199 Church Steps, Whitby, Yorkshire.

Centre. FRANK M. SUTCLIFFE: fish stall on the New Quay, Whitby. This is possibly not from a wet-plate negative. Sutcliffe's work is not dated and it is extremely difficult to tell from what period in his career the photographs were taken.

Bottom. FRANK M. SUTCLIFFE: An Unwilling Pupil. Taken on Tate Hill, Whitby. The man on the left of the barrel is called Raistrick, and his son is administering the clay pipe.

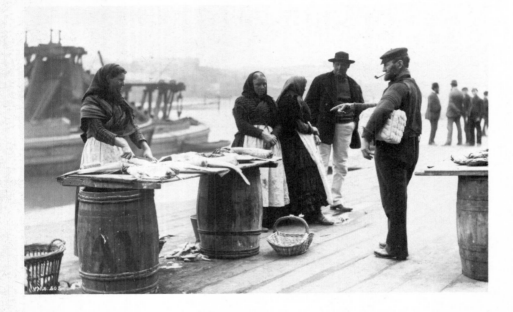

Top right. FRANK M. SUTCLIFFE: 'flither picking'. The fisherwomen here are 'flither picking' on a rocky outcrop of the coast near Whitby known as the Scaur. Flither picking is the local name given to gathering shell fish, mainly mussels, for line bait. The women also had the task of cleaning the fish from the shells and baiting the lines.

Bottom right. FRANK M. SUTCLIFFE: Barry's Square, the Crag, Whitby. This was a picturesque area of Whitby, now largely demolished, in which a good proportion of the fishing community lived.

5 The Royal Family

Queen Victoria and her family were among the first celebrities to be recorded for posterity by the new and wonderful discovery – photography. The Queen, like everyone else who heard in 1839 of the invention of photography by Louis Jacques Mandé Daguerre in France and William Henry Fox Talbot in England, was impressed with this phenomenal advancement. She loved accuracy in her reproductions and was immediately delighted with the early daguerreotypes and calotypes that were presented to her.

The first photographer to be appointed 'Photographist to Her Majesty and His Royal Highness Prince Albert' was William Edward Kilburn, a leading London daguerreotypist. Although the first photographic portrait studios were opened in London in 1841, Kilburn did not take photographs of the royal family until April 1847. A large proportion of their photographs were not taken by professionals but rather by practising amateurs of the royal household. Henry Collen, a miniature painter and drawing master of the Queen, was the first licensee of the calotype

CALDESI: *the royal family at Osborne, 1857, with (left to right) Princess Alice; Prince Arthur; Albert, Prince Consort; Albert Edward, Prince of Wales; Prince Leopold; Princess Louise; Queen Victoria holding Princess Beatrice; Prince Alfred; Victoria, Princess Royal; and Princess Helena.*

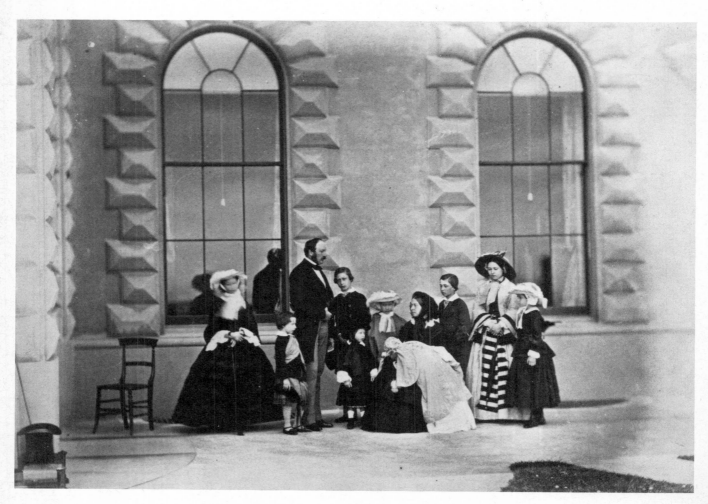

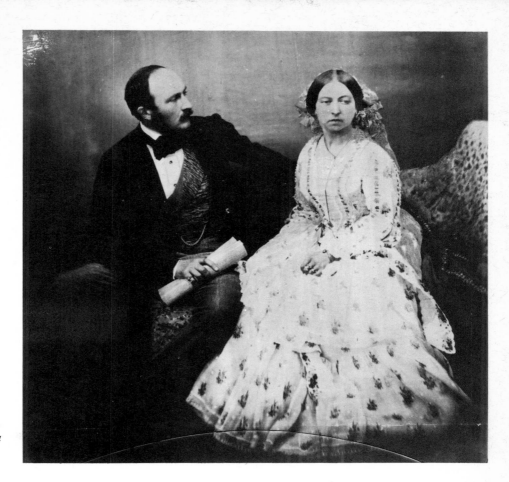

ROGER FENTON: *Queen Victoria and Prince Albert, 1854.*

process and took what appears to be the earliest surviving photograph of the Queen, dated about 1844–5. Nikolaas Henneman was appointed 'Her Majesty's Photographer on Paper' soon after Kilburn's appointment. It is not known if Henneman, a close associate of Talbot, ever photographed the royal family.

The early photographs of the royal family are intimate studies showing Queen Victoria as she preferred to be seen – as wife and mother, not as sovereign. The photographs of the Queen, Prince Albert, and their children are delightful in their informality and captivating in their simplicity and unpretentiousness. As photography became more common from the 1870s onwards, the photographs of the royal family lose much of their personal appeal. Certainly the photographs taken in the 1850s and 60s are some of the most sensitive ever taken of a royal family.

Queen Victoria was convinced that photography was a useful and educational art (an important criterion in Victorian times), and encouraged its advancement as best she could. In May 1853, she and Prince Albert became patrons of the newly formed London Photographic Society. It appears that both of them understood and practised the new 'art', although none of their photographs remain. Each year they would visit the society's exhibition, often accompanied by some of their children. In 1857 she gave a photographic outfit to the King of Siam after the ratification of a treaty of friendship and commerce between the two countries.

Queen Victoria helped popularise photography in two important ways. At the Great Exhibition of 1851 she saw and greatly admired the stereoscope designed by Sir David Brewster and constructed by Jules Duboscq. As a result of her interest there was a great demand for stereoscopes – one of the important landmarks in photographic history. At first stereoscopes used daguerreotypes and glass transparencies, but the high cost of these meant only the wealthy could enjoy stereography. However, once the stereocards could be made from paper prints, stereo-views from all over the world were available to every middle-class Victorian. By 1858 the London Stereoscopic Company was advertising 100,000

different views from every corner of the globe and the 'optical wonder of the age' was seen in drawing-rooms everywhere.

The second means by which Queen Victoria encouraged photography was through her acceptance of *cartes-de-visite*. These photographs, the size of visiting cards, were made popular in France in 1859 when Napoleon II stopped at the studio of the French photographer Disdéri to have a *carte* portrait taken. *Cartes* were not accepted in English society, however, until the Queen consented to have her portrait and those of her family taken by the prominent portrait photographer J. E. Mayall. In August 1860 his 'Royal Album' of *carte* portraits of the royal family taken in May and July was published. Everyone wanted a photograph of their beloved sovereign, and hundreds of thousands of *cartes-de-visite* were sold all over the world in booksellers and stationers' shops. Other celebrities were photographed and the 'cdv' became the rage of the 1860s. Their relatively low cost made it possible for even the working class to buy *cartes*, and to have them taken.

The Queen was very fond of giving photographs as gifts on every possible occasion, and participated widely in the new pastime of exchanging *cartes* and placing them in family albums.

After Albert's death, the Queen always wore a bracelet with an enamelled photograph of him and some locks of his hair. She also ordered that a photograph of her late husband and a wreath be hung on the right side of any bed in which she slept. She required a photograph to be taken of every room Albert had personally used, in order that she could always keep the rooms exactly as he knew them.

There are thousands of photographs which Victoria and Albert had commissioned, bought, or received as gifts at the Royal Library, Windsor. They are found mostly in albums, many of which they compiled themselves, ranging from family photographs to photographs of military campaigns and pictures of anyone who was in the service of Queen Victoria for a number of years. There are albums of photographic reproductions of paintings, engravings, christenings, confirmations and weddings. Queen Victoria loved photography because it gave her exact representations of the people and events closest to her. The public, too, loved the novelty photography and one of their reasons may have been the fact that it allowed them to have a faithful image – a photograph – of their dear Queen.

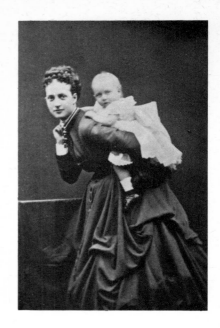

W. & D. DOWNEY: *Alexandra, Princess of Wales with her eldest daughter Princess Louise, taken after Princess Alexandra's recovery from rheumatic fever, 1867. This was the most popular* carte-de-visite *ever printed in Britain. Over 300,000 copies were sold.* (The Photographic News, 1885).

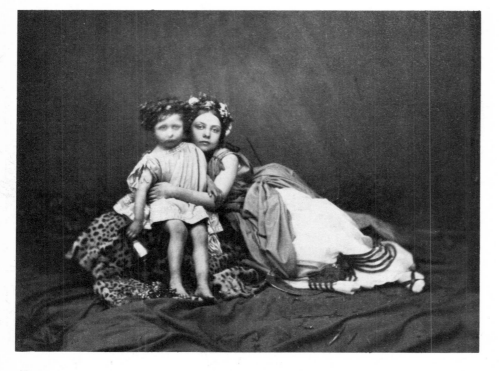

The Princess Royal and Prince Arthur as 'Summer'.

This and the previous photograph were taken by Roger Fenton on 10 February 1854. They show the children reciting excerpts from James Thomson's poem 'The Seasons' in honour of their parents fourteenth wedding anniversary. The photographs were taken by the waxed-paper process and printed on salted paper. Many years later Queen Victoria said she did not approve of these photographs for publication and asked for the negatives to be destroyed. After 120 years there is no risk of an invasion of privacy and no objection is raised to publication.

UNKNOWN: *the royal party at the Crystal Palace, 9 May 1856. This was most likely taken on the occasion of the unveiling of a model of Marochetti's Scutari monument, and a peace trophy (as part of the peace celebrations after the Crimean War). The man towards the right of the picture, with whiskers, is George, Duke of Cambridge. The photograph has the look of what later came to be known as a 'news photo'.*

John Jabez Edwin Mayall (1810–1901) was an American from Philadelphia who lectured in chemistry and ran a daguerreotype studio in that city from 1842. He arrived in London in 1846 and managed the studio of Antoine Claudet (1797–1867), a Frenchman who had bought the first licence from Louis Daguerre to practice daguerreotypy in England. Mayall did not stay long with Claudet as he opened his own studio in April 1847, called the American Daguerreotype Institution. He became very successful as his daguerreotypes, like all American ones, had a greater polish and clarity than the English products.

Mayall soon became one of the leading portrait photographers using both albumen-on-glass negatives and then the superior wet-collodion process. Looking through the *Illustrated London News* and the *Illustrated Times* of the day, one finds hundreds of engravings of prominent individuals based upon photographs by Mayall. His *carte-de-visite* business earned him £12,000 a year, a figure that put him ahead of all other English professional photographers. The output of his establishment was said to exceed half a million *cartes* a year and the royalties paid to him for his photographs of the royal family exceeded £35,000.[1]

Queen Victoria said of Mayall after her first two-hour sitting with him in July 1855, 'He is the oddest man I ever saw, but an excellent photographer. He is an American, and a tremendous enthusiast in this work.'[2]

UNKNOWN: *probably a celebration arch marking the wedding of Albert Edward and Alexandra, 1863.*

Probably G. W. WILSON: *Queen Victoria and John Brown, 1863.*

John Brown, Queen Victoria's highland servant, had an unusually close relationship with her. Originally one of Prince Albert's gillies, Brown became the Queen's regular attendant in the Highlands from 1858. In February 1865 he was promoted to her regular outdoor attendant.

George Washington Wilson (1823–93) of Aberdeen, was best known internationally for his views of Scottish cities, castles, cathedrals, seascapes, and lake and mountain scenes. A wet-plate photographer, he became famous for his 'instantaneous views' (less than one second exposures). The term also referred to subject matter with peopled streets, boats under sail, etc. G. W. Wilson was a popular portrait photographer and in 1860 was appointed the Photographer Royal for Scotland. By 1880 'G.W.W.' was the world's largest publisher of photographic views.

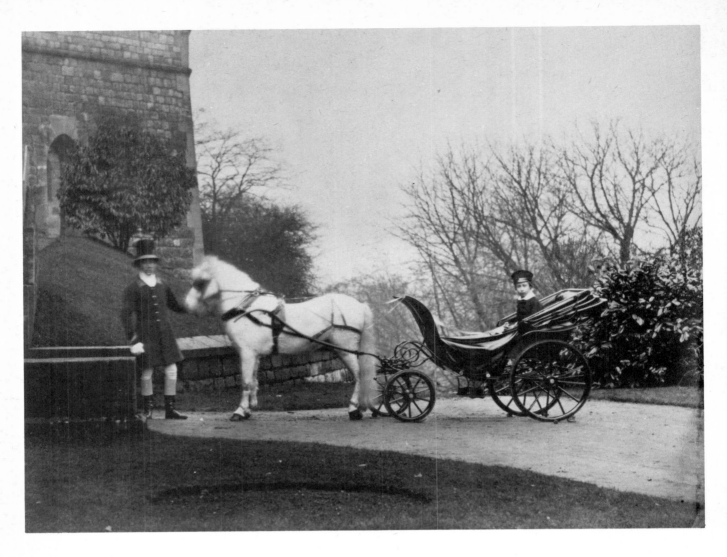

CHARLES NÈGRE: *Prince Leopold, with Lady and Miss Bowater, Villa Liader, Cannes, 7 February 1862.*

Over page (*pp* 104 and 105) EARL OF CAITHNESS or MR BAMBRIDGE: *planting Prince Consort's memorial tree, Windsor Great Park, 25 November 1862. This appears in the book* The History of Windsor Great Park and Windsor Forest (1864), *William Menzies. The Queen was accompanied by Princess Alice, Princess Alexandra of Denmark, the Countess of Caledon, Prince Louis of Hesse, Prince Leopold, Princess Louise and Count Gleichen.*

Opposite, top. UNKNOWN: *the Prince of Wales in the Queen's pony chair, 10 February 1857.* Bottom. UNKNOWN: *Scots with royal dogs.*

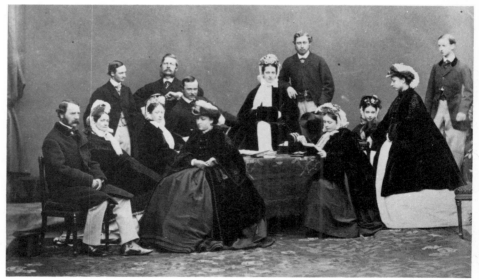

J. E. MAYALL: *wedding guests, taken the day before the wedding of the Prince of Wales and Princess Alexandra of Denmark, 9 March 1863, with (left to right) Prince Christian of Denmark; Louise, Princess Christian of Denmark; Prince Frederick of Denmark (standing); Alice, Princess Louis of Hesse; Crown Prince Frederick William of Prussia (standing); Prince Louis of Hesse; Princess Helena (foreground); Princess Alexandra of Denmark; Albert Edward, Prince of Wales; Victoria, Crown Princess Frederick William of Prussia (reading); Princess Dagmar of Denmark; Princess Louise; and Prince William of Denmark.*

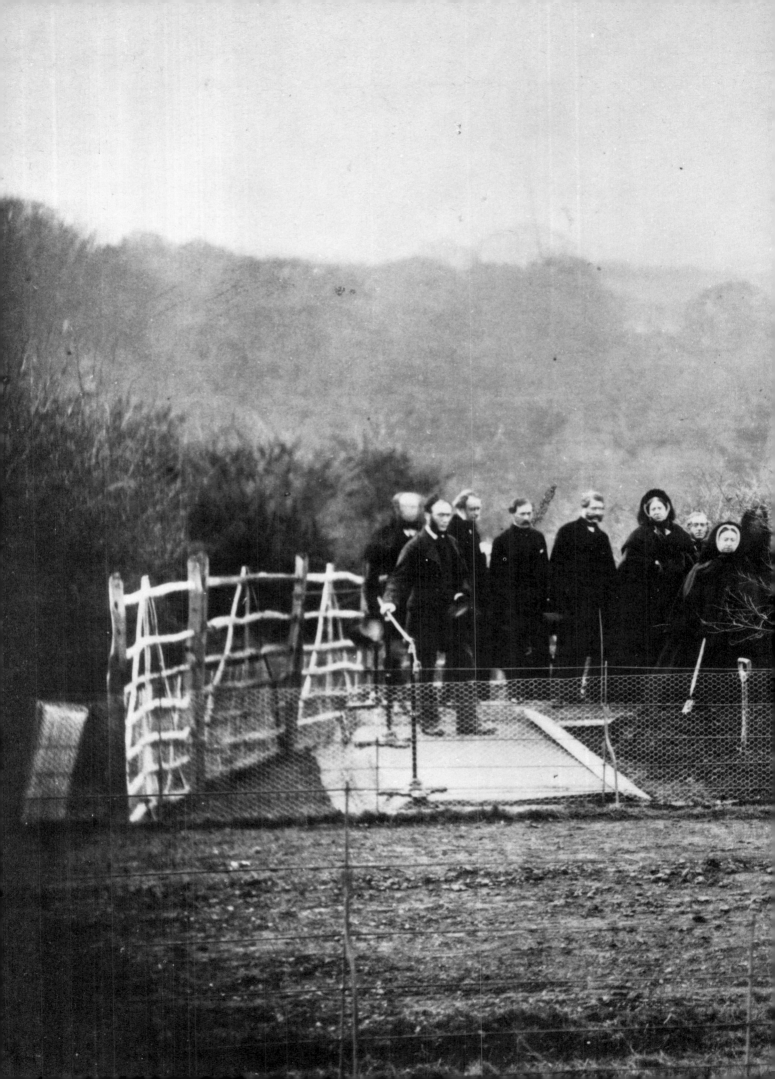

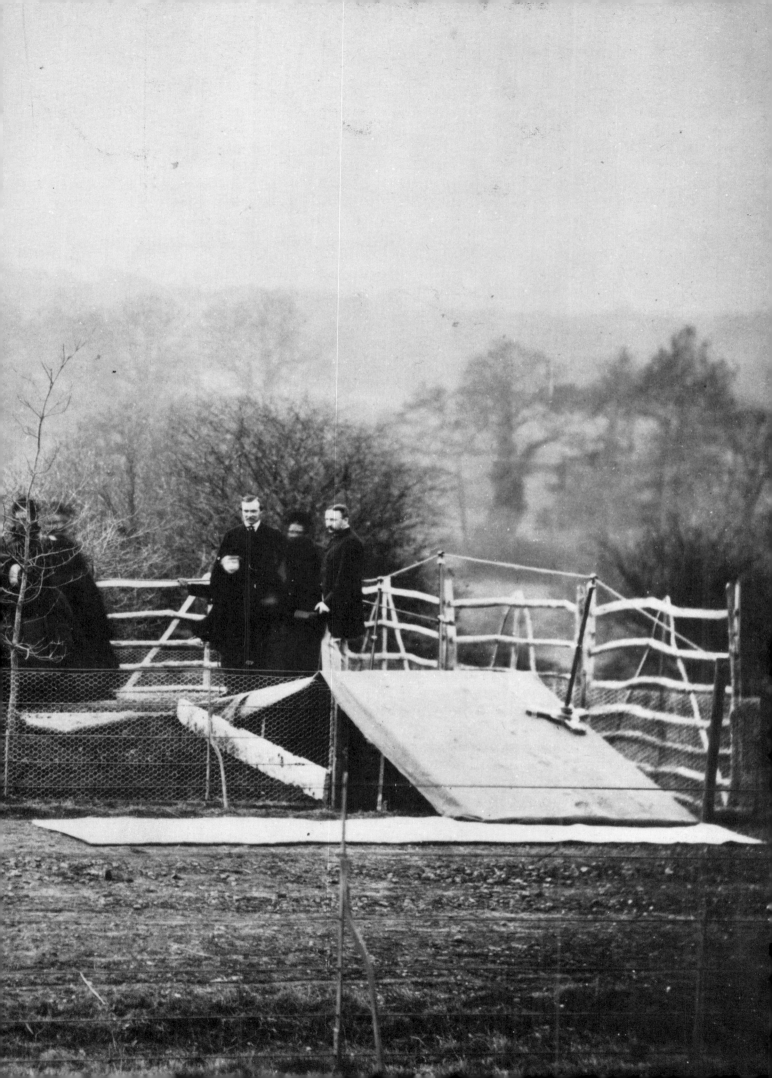

PRINCE ALFRED: *set of four carte-de-visite photographs of Queen Victoria and Princess Alice, Windsor Castle, 1862. Prince Alfred was an enthusiastic amateur photographer. All the princes, except Arthur, apparently attempted the new medium.*

ROGER FENTON: *the long walk, Windsor, c 1860. Fenton was one of the first photographers to be summoned by Queen Victoria to Windsor and Balmoral Castles, and was a frequent visitor from 1853 until Prince Albert's death.*

6 A Personal Family Album

Recording one's own family and friends is the most common, and one of the most satisfying uses of the camera. Personal photographs tend to fall into one of two groups. The first we call the snapshot. Simple and straightforward, the photographer has pointed his camera at a face, figure, or event he wants to remember. The snapshot is for the individual's own gratification. He can, once the print is in his hand, interpret the picture on many different levels.

In the second instance the person behind the camera is putting something of himself into the act of photographing. He is trying to create an image; not just snatch one. He is thinking in terms of communicating part of what he feels about the occasion, the place or the person. He considers composition, time, and movement and tries to give a comprehensible form to his perceptions.

THE WOODEN FAMILY. *Colonel Henry Wood's caption for this photograph.*

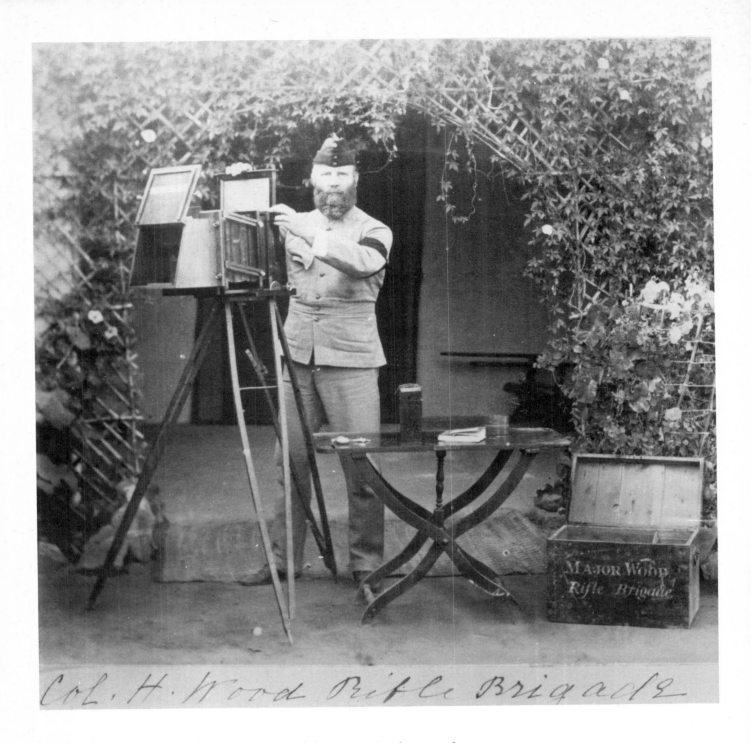

Col. H. Wood Rifle Brigade

The photography of Colonel Henry Wood (1834–1919) whose work we see exclusively in this chapter epitomises the second type of personal photography previously referred to. Most of the knowledge we have about Henry Wood is found within his photographs. He understood the importance of documentation and photographed the dishes on the shelf, formal groups of his fellow officers, the houses where he lived. He also knew how to extend the idea of documentation to make significant personal images. He photographed his wife in bed after having her first baby, and we see the scene as the husband saw it, discreetly yet intimately. His photographs of his daughters eating cherries or by a bird cage are so quiet, so idyllic that the viewer truly feels the peace and contentment of childhood.

Henry Wood apparently started to photograph in the 1860s using wet-plate apparatus. The split-second exposure was not possible, and the concept of 'snap-shooting' was unheard of; photography was a difficult and laborious task. The photographer had to sensitise his own plates, give lengthy exposures, develop the

plates and carry around with him a mountain of equipment and chemicals to perform these operations. The 'primitive' photographer did not shoot haphazardly, yet few amateurs went beyond mastering the technique. Those individuals that saw certain possibilities of the photographic medium were mostly professionals who wanted a new gimmick to help sell their photographs or a new way to impress their audience at exhibitions with their complex 'works of art'. Henry Wood went beyond straight picture-making but not for these reasons. He had an intuitive understanding of photography and always remained an amateur. It is difficult to know if he arrived at his awareness independently, but we do know he foresaw many later photographic trends.

Henry Wood understood the psychological complexities of photomontage. He created new realities to illustrate his fantasies, his dreams. Not only did he realise that the psychological sum of one photograph printed on top of another is far greater than the two independently, he also had a conception of layout. It is very important in arriving at an understanding of Henry Wood's work to view the albums in which he pasted his photographs. He was totally conscious of the way one photograph relates to another on the page. He layed out his photographs mostly for entertainment and enjoyment; he captioned practically every image. He also included in his albums his drawings, Christmas cards, pressed leaves, cartoons, etc. Henry Wood was living in an age prior to record players, radio and television, and people flipped through family albums as a pastime and for amuse-

Henry Wood's photographic chemicals, dark tent used when sensitising and developing the plates, baths, camera, tripod, lenses, and carrying cases.

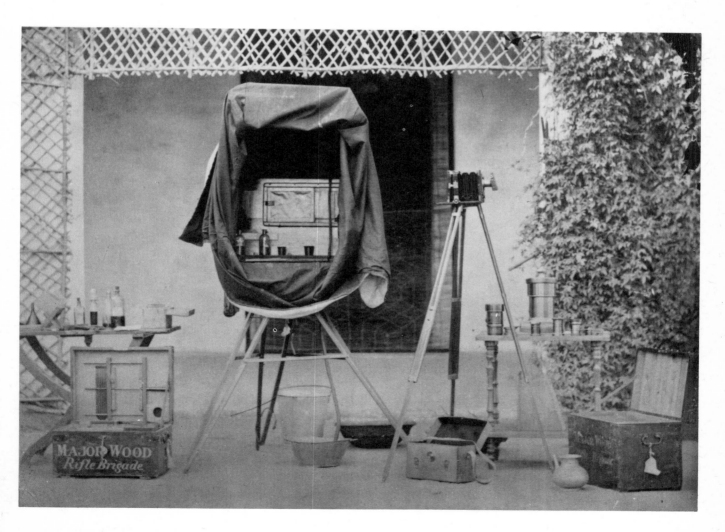

ment. Compared to other Victorian family albums, his are totally fresh in approach and style.

Henry Wood's 'straight' photography is outstanding in itself. He photographed his life with his first wife Charlotte and then with Helen, his second wife, and their daughters. He put great creative, psychological and emotional energies into his photographs. This is the fundamental reason why they 'live' today. The spirit and energies he injected into his photographs flow out each and every time we view them. His sincerity, talent, and conscientiousness are unquestionable. He knew his subjects intimately and made no effort to photograph things unrelated to his life. Unlike the professional portrait photograph that appears stiff and cold because it was taken by an anonymous operator of what some considered an unholy machine, Henry Wood's portraits are moments of living. His daughters are playful, relaxed and walk right out of Henry's pictures into our hearts. Their father knew their impish ways and encouraged them to sometimes see photography as play-acting, allowing them to dress up, create a mood, or just be themselves. His second wife Helen does, however, appear aloof in most of the photographs. Again, this is a reflection of her personality which was rather cold and unyielding. He was firm but gentle with his family and friends and his photographs, well conceived and composed, have an unposed naturalness about them. Henry Wood, a marvellously talented photographer, loved his subjects and his medium for expression.

Henry Wood was born in Richmond, Surrey and was educated at St Peter's College, Radley. He left there in 1848, and in 1853 joined the 69th Regiment. A year later he was in the Crimea. After the war he was with the Rifle Brigade in England until 1864, when he was sent to the north-west frontier of India. Two years later he married Charlotte Francis Smith. Their marriage was a short but happy one. It is Charlotte who appears in the first set of photographs in this chapter. She was an adventurous Victorian lady, and she and her husband covered much rugged territory on their honeymoon in 1866. Charlotte even removed her crinoline when hiking! She died in 1869, at the age of twenty-two, in England, leaving two children.

In 1871 Henry Wood married Helen Mary, daughter of the Reverend Henry Brown, rector of Woolwich. They had four daughters – Hazel (b 8 August 1872), Olive (b 1 March 1878), Myrtle (b 15 May 1881) and Holly (b 3 January 1889). In 1880 the family went to India where Henry Wood commanded a battalion of the Rifle Brigade between 1880–5. Many of the photographs of 'Mother' and the girls date from this period. Their home appears to have been very pleasant and certainly they entertained many friends. He even posed his visitors in different costumes and situations.

The Wood family returned to England in about 1887 and Henry commanded the 9th Regimental District in Norfolk. He retired in 1890 and spent his remaining years in Norwich painting, wood-carving, etc. His family always considered him to be rather 'eccentric' (the only souvenir he brought back from the Crimea was a skull), and showed no interest in his photography. Only his granddaughter, Mrs Veronica Bamfield, thought it was outstanding and it is due to her cherishing and preserving 'Grandpa's' photographs that we have the opportunity today to see these tender, humourous, and beautiful images. Most of the photographs reproduced in this chapter are from wet-collodion negatives and printed on albumen paper. Contrary to the pattern established in the other chapters, there are some photographs in this chapter taken in the 1890s and early 1900s on dry plates. The decision to include these was made for three reasons. Firstly, it is fascinating to see how Henry Wood developed as an amateur photographer over nearly half a century. Secondly, it is delightful to see the Wood girls as adolescents and young adults and thirdly, they were too good to leave out!

The photographs on the following three pages were probably taken on Henry and Charlotte's honeymoon in India; those from page 114 onwards were taken after Henry's marriage to Helen.

A 'wolf man'. This man was raised by wolves. When he reached a certain age they made him leave the pack. He never spoke and always remained in the posture shown. Taken about 1866, it is perhaps the first photograph of such a man.

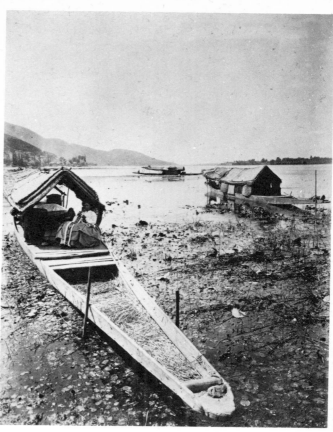

Henry in Poplar Avenue, Cashmere, 1 October 1866.

Charlotte – Cashmere, 2 October 1866.

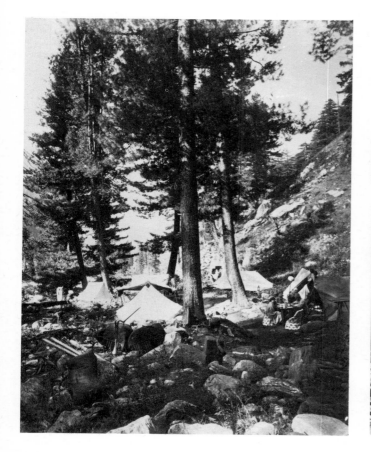

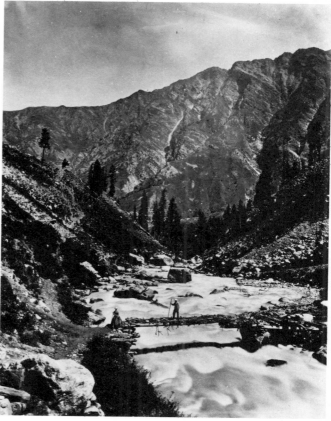

Campsite, Kaghan, 1866.

Charlotte and a friend, 1866.

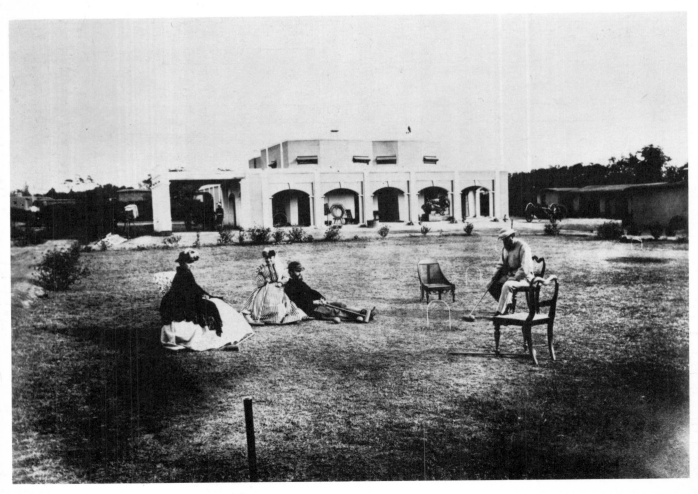

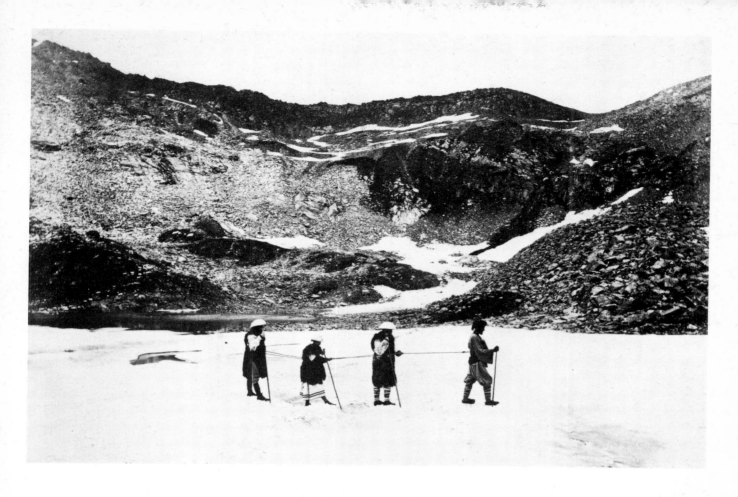

Charlotte has taken off her crinoline in favour of a 'posh teen', a native fur coat. She is roped between Henry and another Englishman. An Indian guide is leading. Kaghan, 29 July 1867.

Charlotte dressed to go out to the stores, 1867.

Left: *Helen in bed after the birth of Hazel; Tzaperjium Cottage, Southsea, August 1872.* Below left: *a page in one of Henry's albums.* Below: *Hazel and Olive, c 1879.*

Doll's Tea. Party. Freddy & Cecil. 1872

Hazel

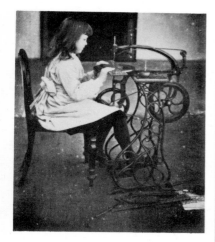

Hazel at Work

Olive – à la Jean Baptiste

Cecil 1873

Freddy and Cecil were Charlotte and Henry's children.

Freddy 1873

Alice Brown, 27 July 1872.

Hazel and Olive, c 1881.

AFTERNOON TEA

Olive on her third birthday, 1881.

Olive Wood, and presumably, one of Henry's brother officers, c 1881.

Thus wandered these two pretty babes
Till death did end their Grief
And in one another's arms they dyed
As babes wanting relief.

(Inscription, and spelling, as in one of Henry's albums)

Helen, Hazel, and a sleeping Olive, 1881.

Myrtle in the sky, and Olive, c 1881.

Olive. Cooking on.
Mother Cooking.
Verandah of
Cooldunnah Cottage
India.

Below: *Olive and Helen Wood at the breakfast table with friends. Henry's place is vacant while he photographs. The dog's name is Teak, another pun on the family surname, c 1882.* Below right: *Myrtle, Helen, and Olive looking on, c 1883.*

'*Little Red Riding Hood (alias Olive)*', c 1883.

Cooldannah Cottage, September 1883 – 'T

Olive and Myrtle, back view, 1884.

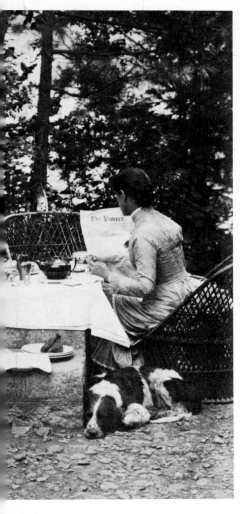

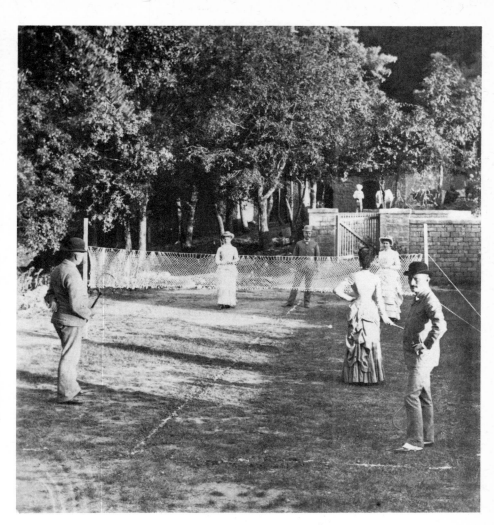

...ician'.

Badminton at Cooldannah Cottage, September 1883.

Olive and Myrtle, front view, 1884.

Mother and Myrtle in India.

WAR BEFORE

This and the following photographs were taken on dry plates when the family was back in England (pp 123-4).

Left: *Olive and Bee at Teak's grave, c 1884.* Below: *Olive, Hazel, and Myrtle in the garden of Cooldannah Cottage, c 1886.*

WAR AFTER

After many years in the army – a statement. Holly Wood, Norwich, c 1902.

Right: *Myrtle and Olive in the cosy corner of the drawing room at Thorpe Road, Norwich, c 1896. Below: Henry called this 'A Freak Picture' – Fred, Holly, Hazel, Myrtle, Olive, Olive, Hazel, Myrtle, Fred, Holly, c 1897.*

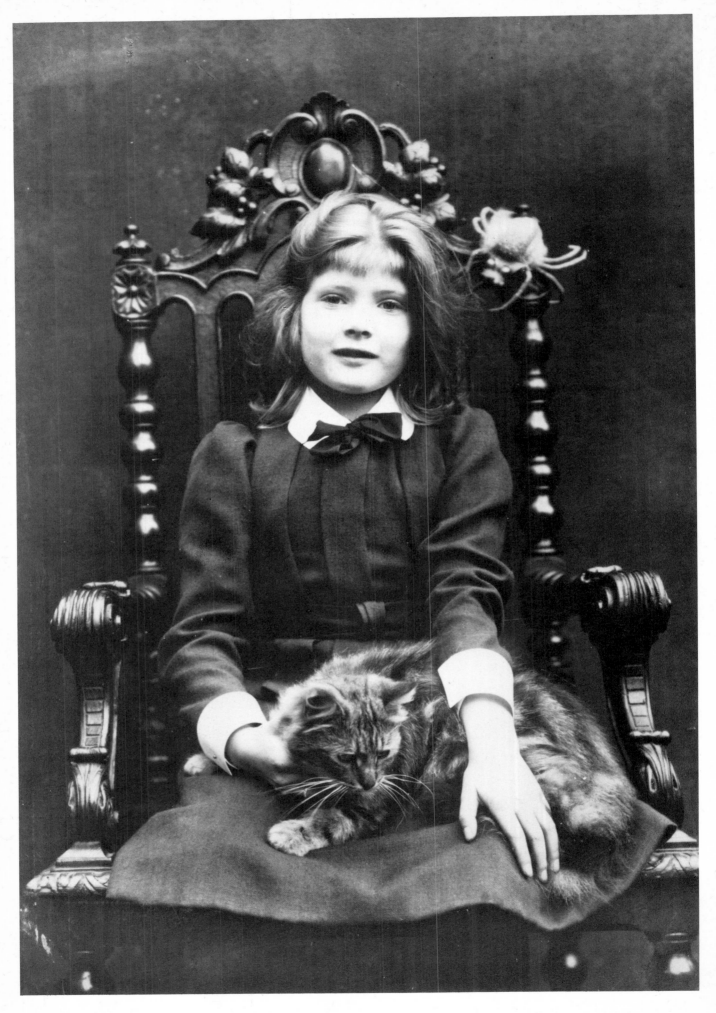

Notes

CHAPTER 1

1 *Photographic Journal*, 1859, p 179
2 *The Photographic Album for the Year 1855* (contributions from the members of The Photographic Club)

CHAPTER 2

1 *Photographic Journal*, 21 June 1858, p 229
2 *British Journal of Photography*, 26 November 1869, p 570
3 ibid, 23 November 1866, p 560
4 ibid, 28 December 1866, p 618
5 ibid, 18 February 1870, p 75
6 Thomas, D. B. 'The Lantern Slides of Eadweard Muybridge', *British Journal of Photography Annual* (1969), pp 17–26
7 Taft, Robert. *Photography and the American Scene: a Social History 1839–1889* (New York, 1938; reprinted New York, 1964), p 309
8 Bourne, Samuel. 'A Photographic Journey through the Higher Himalayas', *British Journal of Photography*, 3 December 1869, p 579
9 Thomson, John. *Illustrations of China and Its People* (1873–4), vol 1
10 Claudet, A. 'Photography in Its Relation to the Fine Arts', *Photographic Journal*, 15 June 1860, p 266

CHAPTER 3

1 Gernsheim, Helmut. *Roger Fenton: Photographer of the Crimea* (1954), p 75
2 *Journal of the Photographic Society*, 21 January 1856, p 286
3 *Congressional Record*, 43rd Congress, 2nd session, vol 3, part 3, p 2250. Taken from Robert Taft's *Photography and the American Scene: a Social History 1839–1889* (New York, 1938; reprinted New York, 1964), p 241
4 *Photographic News*, 15 March 1878, p 121
5 Săvulescu, Constantin. 'The First War Photographic Reportage', *Image*, vol 16, no 1 (March 1973), pp 13–16
6 Chappell, W. 'Camera Vision at Lucknow', *Image*, vol 17, no 2 (Feb 1958), pp 36–40
7 'Military Proceeding' for 1879, no 2986–2990. Indian Record Office, London. Letter from J. Burke Esq, dated Peshawar, 4 April 1879
8 Gardner, Alexander, *Gardner's Photographic Sketch Book of the War*, text to plate 94

CHAPTER 4

1 *The Year Book of Photography and Photographic News Almanack* (1875), p 75
2 Gardner, Alexander. *Gardner's Photographic Sketch Book of the War*, description opposite plate 2. The photograph reproduced here is not the same as the one in *Gardner's Sketch Book*. The same buildings are shown, but changes have occurred which suggest that it was taken at a later date
3 Benjamin, W. 'A Short History of Photography', *Screen*, vol 13, no 1 (Spring 1972), p 7
4 *Image*, vol 2, no 3 (1962), p 11
5 Thomson, John, and Smith, Adolph. *Street Life in London* (1877; reprinted New York, 1969)
6 Thomson and Smith. *Street Life in London*
7 Thomson, John. *Illustrations of China and Its People* (1873–4), vol 2, plate 14, no 39

The youngest daughter almost grown up – Holly and Olive's cat Julie Bonbon, c 1902.

CHAPTER 5

1 *Photographic News*, 1885, p 136
2 Gernsheim, H. and A. *Queen Victoria: a Biography in Word and Picture* (1959), p 261

Bibliography

Place of publication is London except where stated otherwise

GENERAL BOOKS USED IN THE PRESENTATION OF THIS VOLUME

BEAVER, Patrick. *The Big Ship: Brunel's Great Eastern – a pictorial history* (1969)

BELL, Quentin, and GERNSHEIM, Helmut and Alison. *Those Impossible English* (1952)

BONI, Albert. *Photographic Literature: an International Bibliographic Guide* (New York, 1962). The standard general bibliography in photography

BRAIVE, Michel F. *The Era of the Photograph* (1966). Translation by David Britt from the original French edition (Brussels, 1964)

CARRINGTON, Noel, and RAE, Jocelyn. *This Man's Father* (1935)

EDER, Josef Maria. *History of Photography* (New York, 1945). Translation by Edward Epstean from the German fourth edition (Halle, 1932)

GERNSHEIM, Alison. *Fashion and Reality 1840–1914* (1963)

GERNSHEIM, Helmut. *Masterpieces of Victorian Photography* (1951)

GERNSHEIM, Helmut. *Historic Events 1839–1939* (1959)

GERNSHEIM, Helmut and Alison. *Queen Victoria: a Biography in Word and Picture* (1959)

GERNSHEIM, Helmut and Alison. *Roger Fenton: Photographer of the Crimean War* (1954)

GERNSHEIM, Helmut and Alison. *The History of Photography* (revised edition, 1969)

HORAN, James D. *Timothy O'Sullivan: America's Forgotten Photographer* (New York, 1966)

HORAN, James D. *Matthew Brady, Historian with a Camera* (New York, 1955)

IVINS, William M., Jr. *Prints and Visual Communication* (Cambridge, Mass, 1953)

JACKSON, Clarence S. *Picture Maker of the Old West: William H. Jackson* (New York, 1959)

JAMMES, André. *Charles Nègre: Photographe* (Paris, 1963)

JAY, Bill. *Victorian Cameraman: Francis Frith's Views of Rural England 1850–98* (Newton Abbot, 1973)

LIBRARY OF CONGRESS. *Civil War Photographs 1861–5* (Washington DC, 1961). Catalogue of photographs compiled by Hirst D. Milhollen and Donald H. Mugridge

LO DUCA. *Bayard* (Paris, 1943)

MAAS, Jeremy. *Victorian Painters* (1969)

MINTO, C. S. *Thomas Keith: Surgeon and Photographer* (The Hurd Bequest of photographic paper negatives) (Edinburgh, 1966).

MUYBRIDGE, Eadweard. *Animals in Motion* (1925; reprinted New York, 1957)

NEWHALL, Beaumont. *The History of Photography from 1839 to the Present Day* (New York, 1964)

NEWHALL, Beaumont. *The Latent Image: the Discovery of Photography* (Garden City, New Jersey, 1967)

OVENDEN, Graham, and MELVILLE, Robert. *Victorian Children* (1972)

POLLACK, Peter. *The Picture History of Photography* (revised edition, New York, 1969)

QUENNELL, Peter. *Victorian Panorama: a Survey of Life and Fashion from Contemporary Photographs* (1937)

SCHWARZ, Heinrich. *David Octavius Hill: Master of Photography* (1932). Translation by Helene D. Fraenkel from the original German edition (Leipzig, 1931)

TAFT, Robert. *Photography and the American Scene: a Social History 1839–1889* (New York, 1938; reprinted New York, 1964)

THOMAS, D. B. *The First Negatives* (1964)

THOMAS, D. B. *The Science Museum Photography Collection:* Catalogue (1969)

TIME-LIFE BOOKS. Life Library of Photography
Light and Film (Nederland, 1970, 1971)
Great Photographers (New York, 1971)
Photojournalism (Nederland, 1971, 1972)
Documentary Photography (New York, 1972)

EARLY EDITIONS USUALLY FOUND ONLY IN SPECIAL COLLECTIONS

DAVISON, J. B. *The Conway in the Stereoscope* (1860). Illustrated by Roger Fenton
DU CAMP, Maxime. *Egypte, Nubie, Palestine et Syrie: Dessins Photographiques* (Paris, 1852)
FRITH, Francis. *Egypt and Palestine Photographed and Described* (1858–9) in 2 vols
GARDNER, Alexander. *Gardner's Photographic Sketch Book of the War* (Washington DC, *c* 1865, 1866; reprinted New York, 1959) in 2 vols
HOWITT, William and Mary. *Ruined Abbeys and Castles of Great Britain* (various editions). Photographic illustrations by Roger Fenton, Francis Bedford, etc, 1862, etc
MURRAY, James William. *Photographic Views of Japan, with Historical and Descriptive Notes* (Yokohama, 1868). Photographs by Felice Beato
SMYTH, C. Piazzi. *Teneriffe, an Astronomer's Experiment or Specialities of a Residence Above the Clouds* (1858). Illustrated with photo-stereographs
TALBOT, William Henry Fox. *The Pencil of Nature* (1844–6, in 6 parts; reprinted New York, 1969)
TAUNT, Henry William. *A New Map of the River Thames, from Thames Head to London*, 3rd edition (Oxford, 1879)
THOMPSON, W. M. *The Holy Land, Egypt, Constantinople, Athens*, etc (1866), with a series of forty-eight photographs taken by Francis Bedford
THOMSON, John. *The Antiquities of Cambodia* (Edinburgh, 1867)
THOMSON, John. *Illustrations of China and Its People* (1873–4) in 4 vols
THOMSON, John. *The Straits of Malacca, Indo-China, and China* (1875)
THOMSON, John. *Through Cyprus with the Camera in the Autumn of 1878* (1879) in 2 vols
THOMSON, John, and SMITH, Adolphe. *Street Life in London* (1877 in 12 parts; reprinted New York, 1969)

A SELECTIVE LIST OF PERIODICALS RELEVANT TO THE EARLY HISTORY OF PHOTOGRAPHY

Amateur Photographer, 1884–
British Journal of Photography, 1860–
British Journal of Photographic Almanac, 1860–1961
Image, Rochester, New York, 1952–
Journal of the Photographic Society of London (later the *Photographic Journal*) 1853–
Photographic News, 1860–1908
Proceedings of the Royal Geographical Society, 2nd series, 1879–1892
Newsletter, 1972– . Royal Photographic Society Historical Group
Stereoscopic Magazine, July 1858 to February 1865. Subject matter not concerned with photography. Illustrated with stereoscopic photographs

EXHIBITION CATALOGUES

A Centenary Exhibition of the Work of David Octavius Hill (1802–70) and Robert Adamson (1821–48) (Edinburgh, 1970). An exhibition held at the Scottish Arts Council Gallery 2 May to 31 May 1970
Eadweard Muybridge: The Stanford Years, 1872–1882 (Stanford, California, 1972). An exhibition held at the Stanford University Museum of Art 7 October to 4 December 1972
French Primitive Photography (New York, 1969). An exhibition held at the Philadelphia Museum of Art 17 November to 25 December 1969
'From today painting is dead' *The Beginnings of Photography*, an exhibition held at the Victoria and Albert Museum, London 16 March to 14 May 1972
Image of America: Early Photography, 1839–1900 (Washington DC, 1957). An exhibition held in the Library of Congress and opened on 8 February 1957
Masterpieces of Victorian Photography 1840–1900, from the Gernsheim Collection, an exhibition held at the Victoria and Albert Museum, London 1 May to 11 October 1951

Index